This Coloring Book
Belongs To

The Artists in the Order of Appearance

Will Cotton
Assume Vivid Astro Focus
Robert Longo
John Baldessari
Andy Warhol
Siah Armajani
Libby Black
William Wegman
Sol LeWitt
Donald Baechler
Maurizio Pellegrin
Jason Middlebrook
Ryan McGinness
Jennifer Steinkamp
Keith Haring
David Humphrey
Neil Jenney
Ed Baynard
Jeremy Blake
Leo Villareal
Ann Craven
Jim Medway
David Row
R. Crumb
Julian Opie
Virgil Marti
Deborah Grant
John Lurie
John Wesley
Duncan Hannah
Grace Hartigan
Tom Otterness
Vito Acconci
John Newman
Lamar Peterson
Laura Owens
Lane Twitchell
Rita Ackermann
Michele Oka Doner
Alexis Rockman
Chris Astley
Graham Parker
Mark Grotjahn
Gary Hume
Kenny Scharf
Willie Cole
Geraldine Lau
Charles Hinman
Joel Fisher
Jane Hammond
Sarah Trigg
Alexander Calder
Christopher Wool
Dennis Hopper
Robert Mapplethorpe
Anonymous

ARxT

RxArt is a not-for-profit organization that promotes healing through exposure to original fine art in patient, procedure and examination rooms of healthcare facilities. We believe healing is optimally accomplished by the integration of spiritual well-being and the finest medical care. RxArt humanizes sterile hospital settings and improves morale by providing a creative surrounding that helps to relieve the stress and anxiety of patients, families and staff.

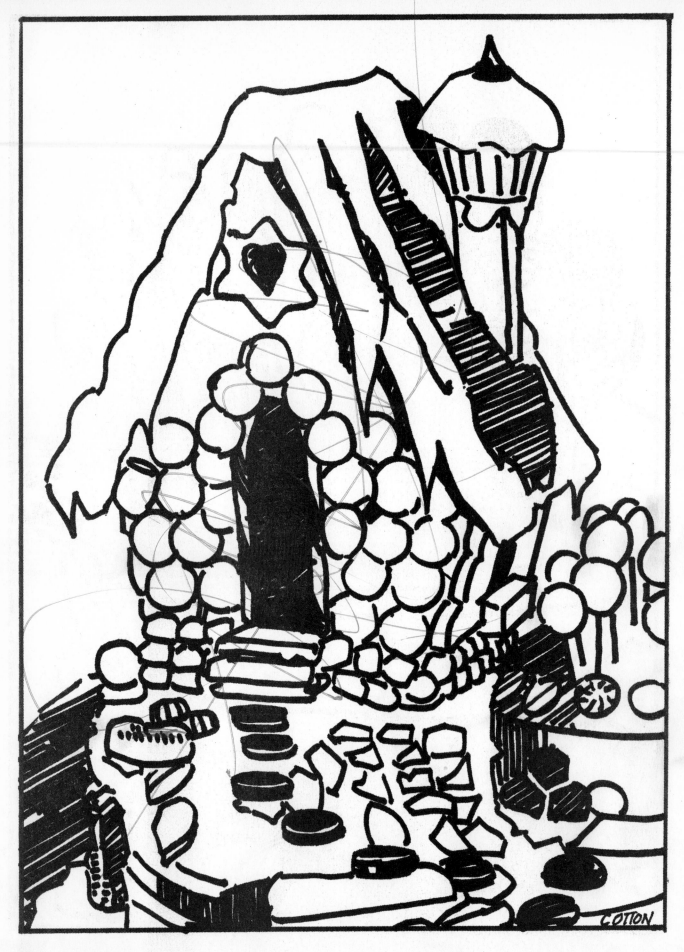

Will Cotton

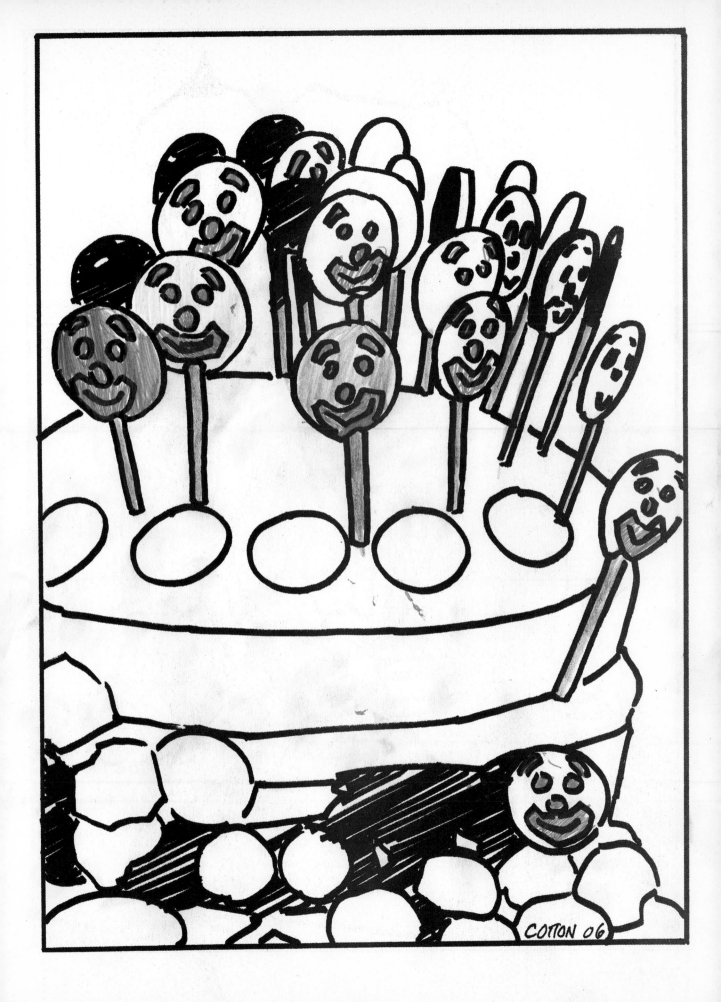

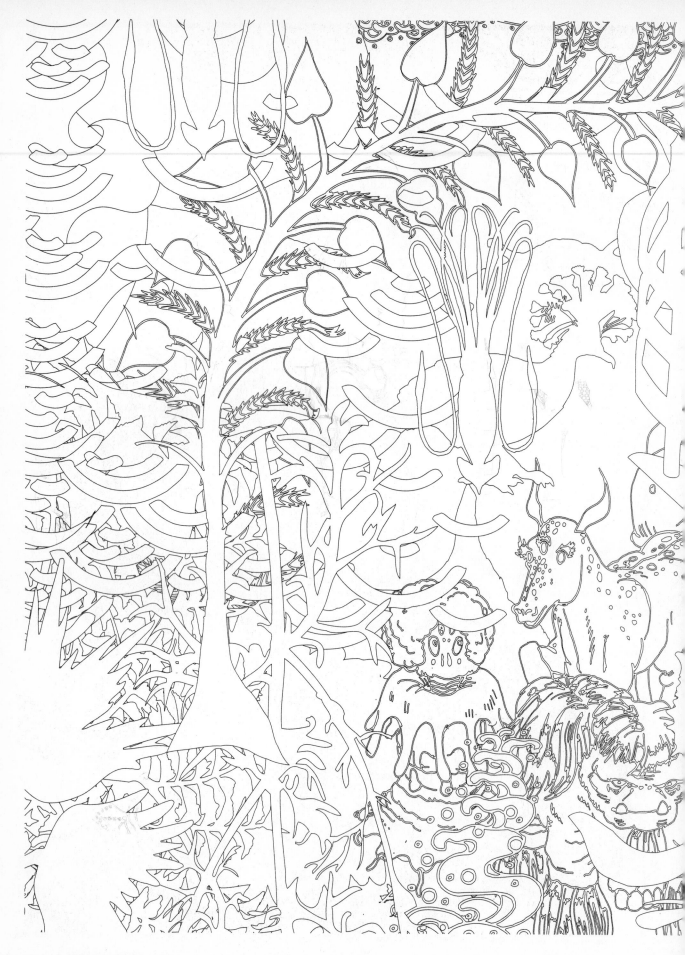

Assume Vivid Astro Focus

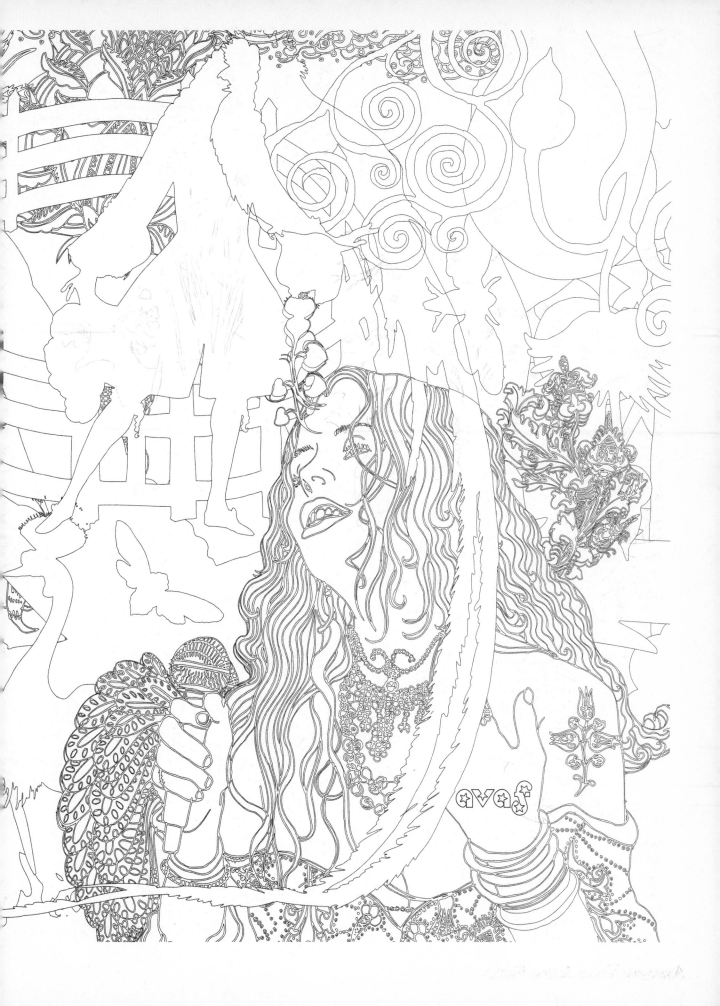

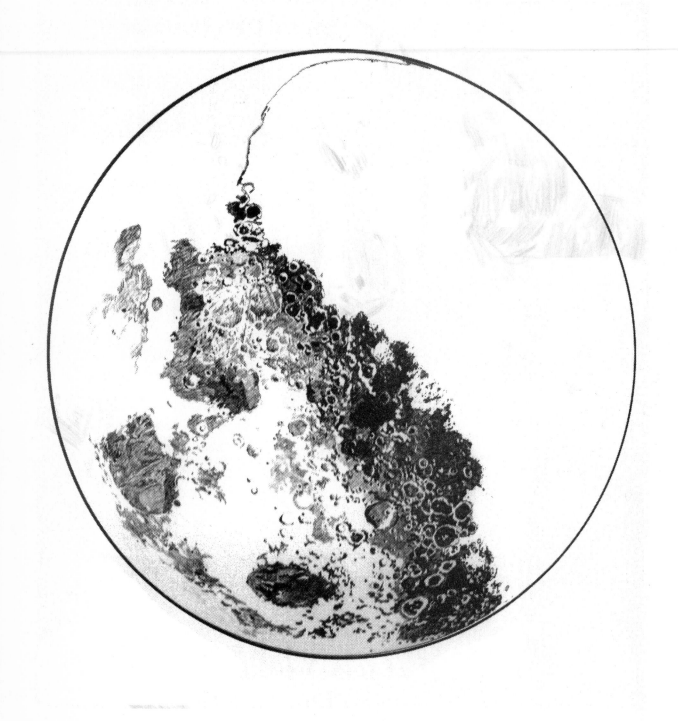

Robert Longo

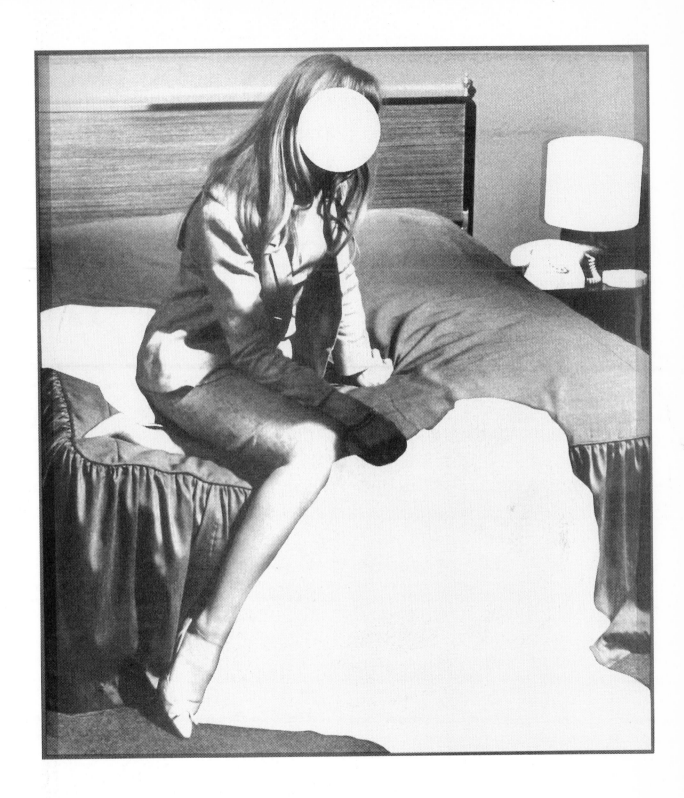

John Baldessari

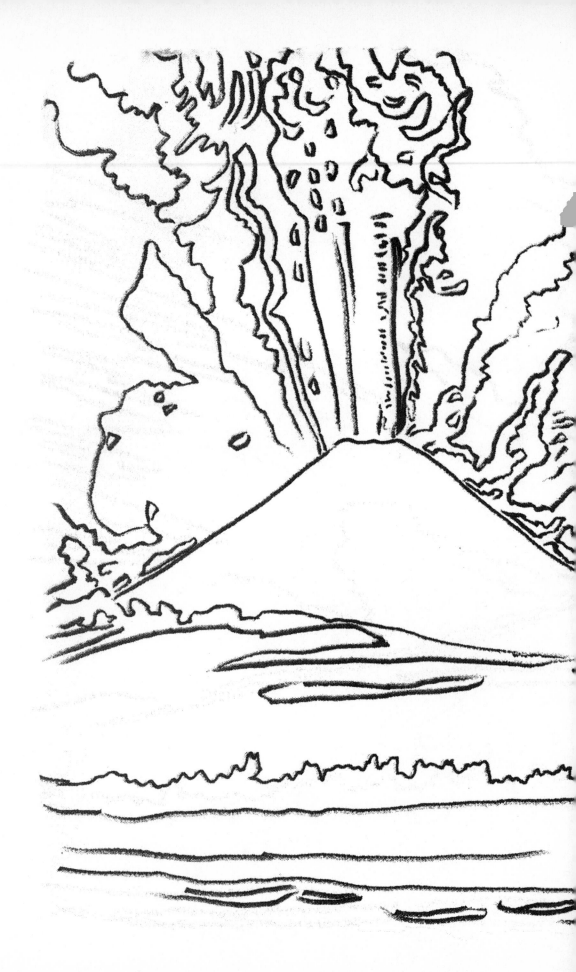

Andy Warhol

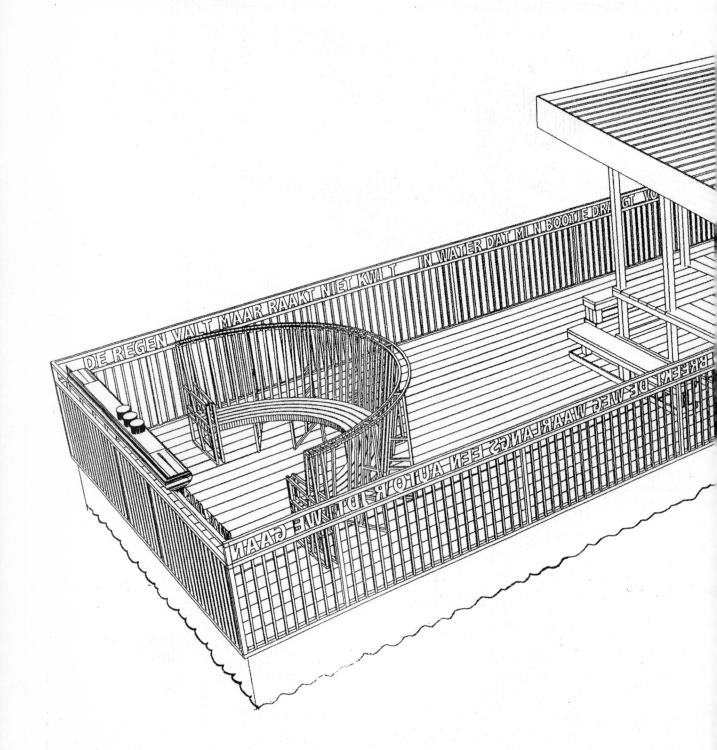

Siah Armajani

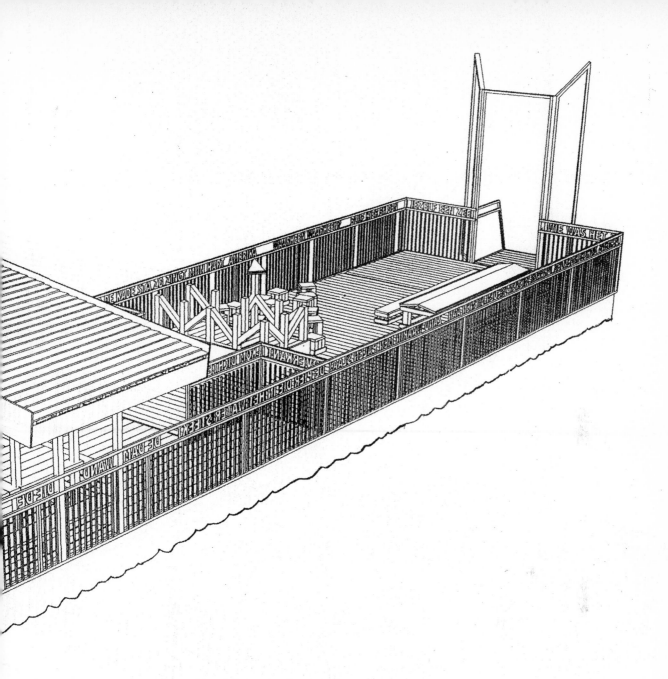

FLOATING POETRY ROOM
IJBURG, HOLLAND
- S.A. 06

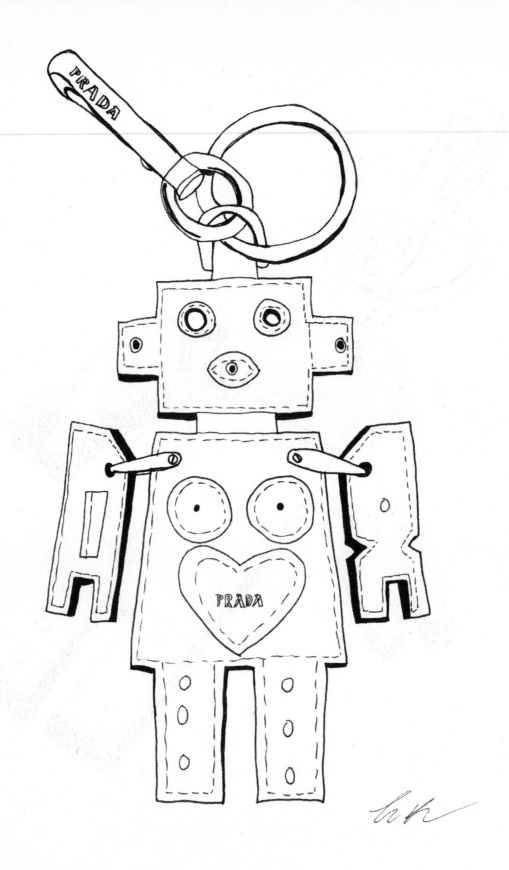

Libby Black

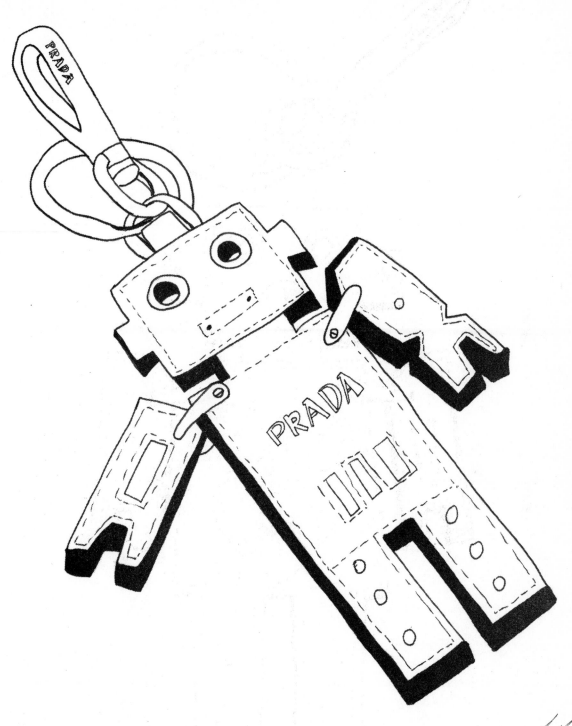

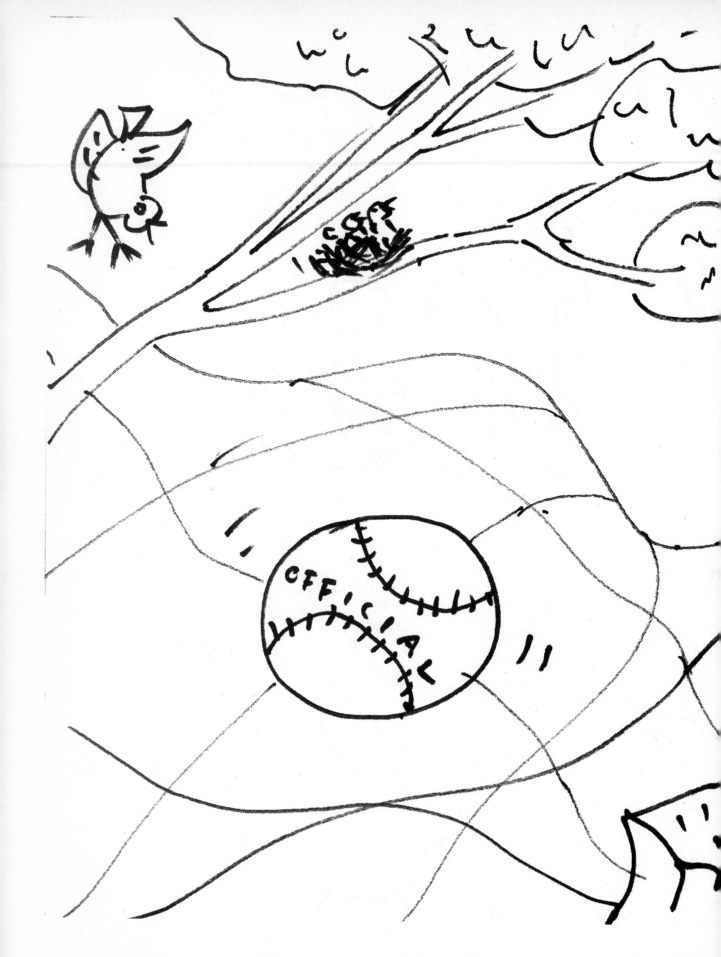

William Wegman

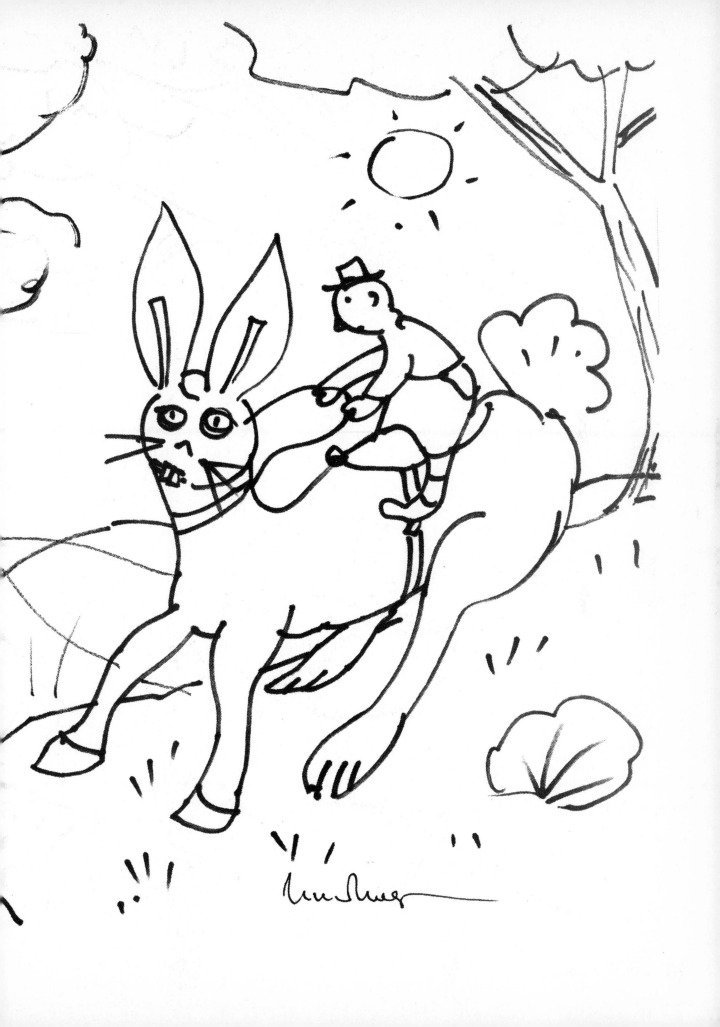

Sol LeWitt

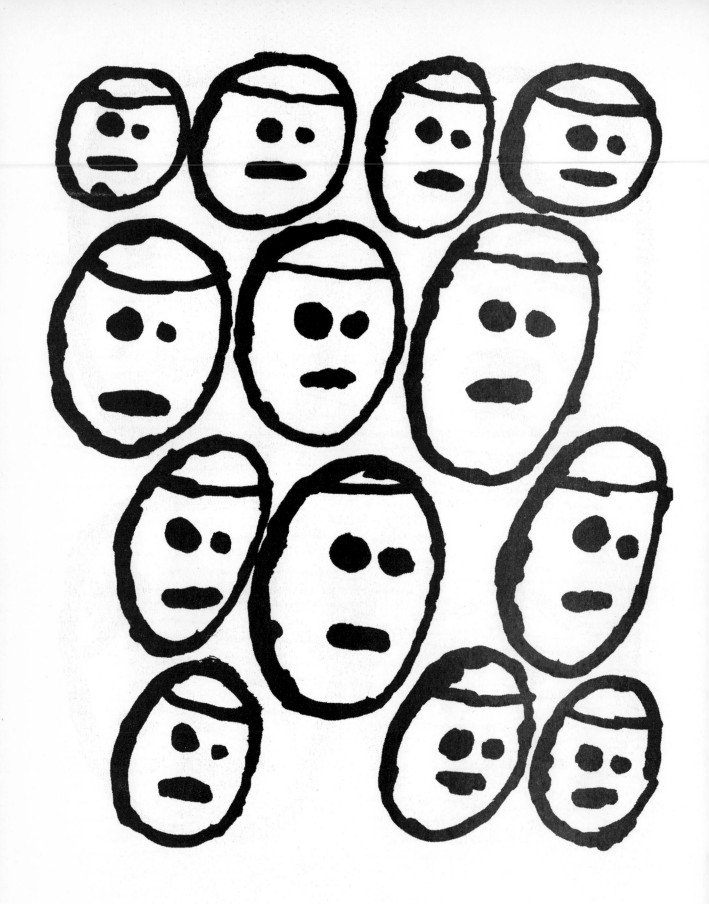

Donald Baechler

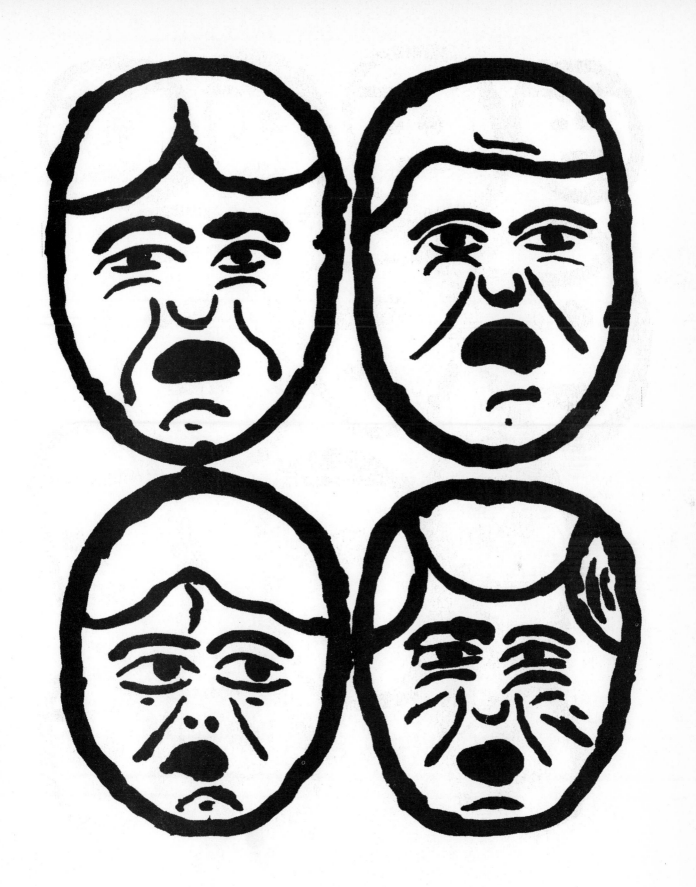

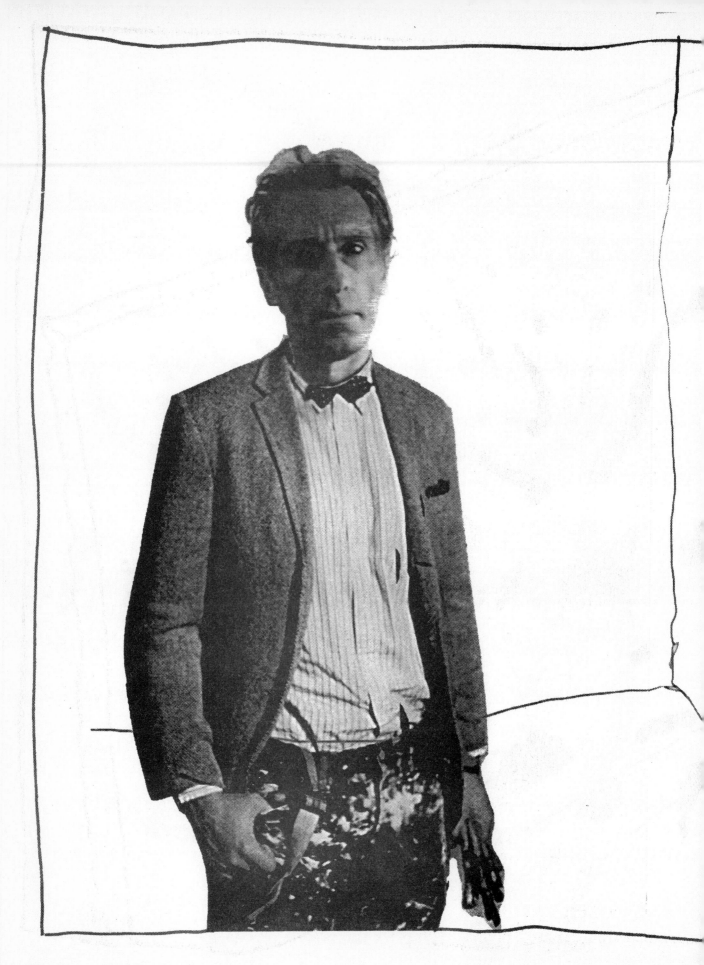

Maurizio Pellegrin

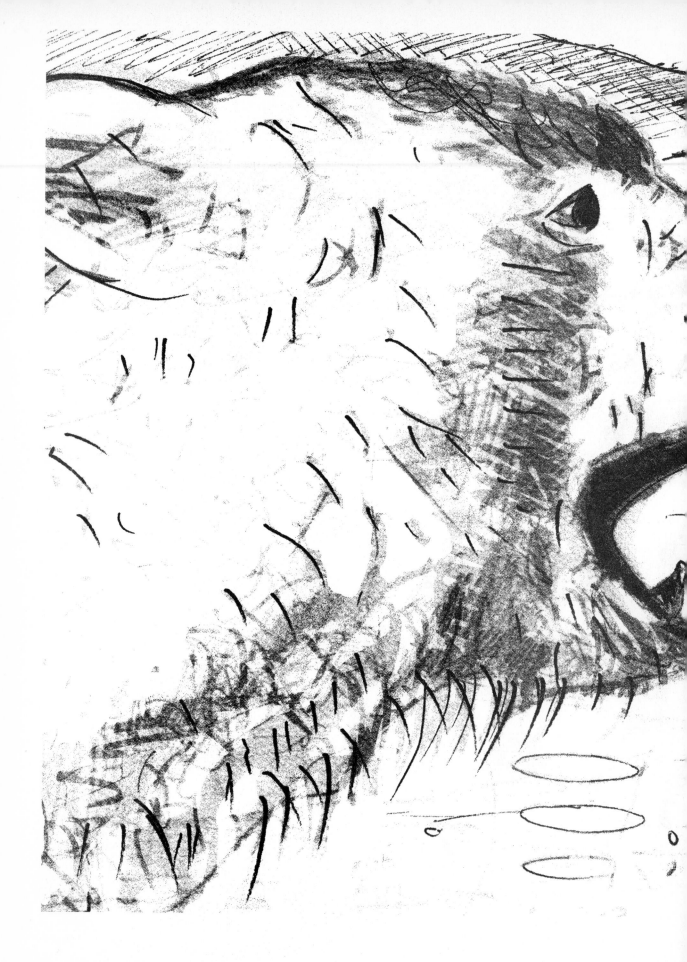

Jason Middlebrook

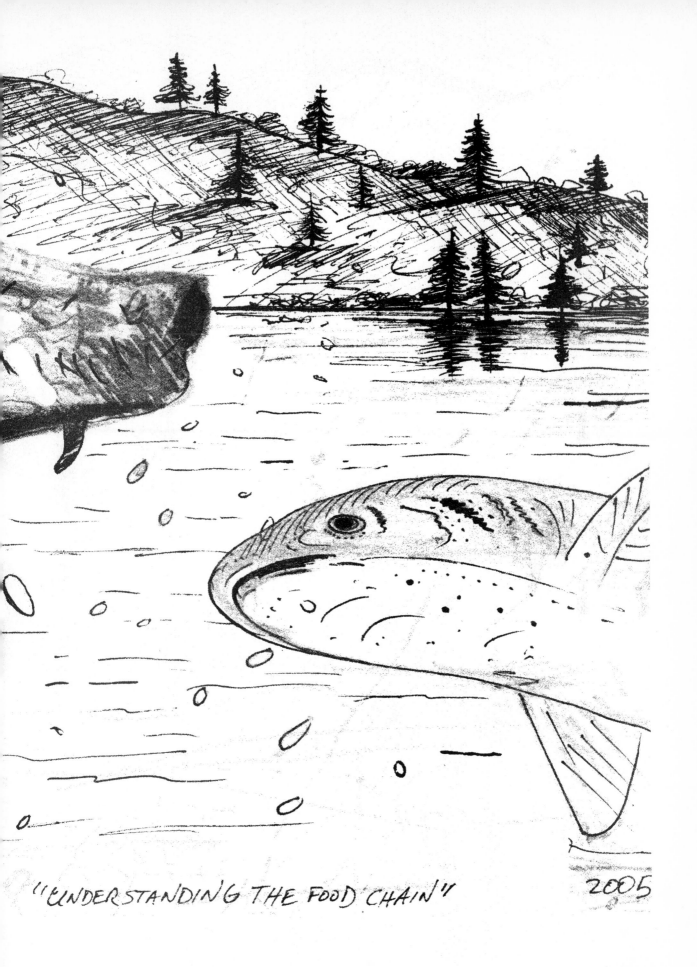

"UNDERSTANDING THE FOOD CHAIN" 2005

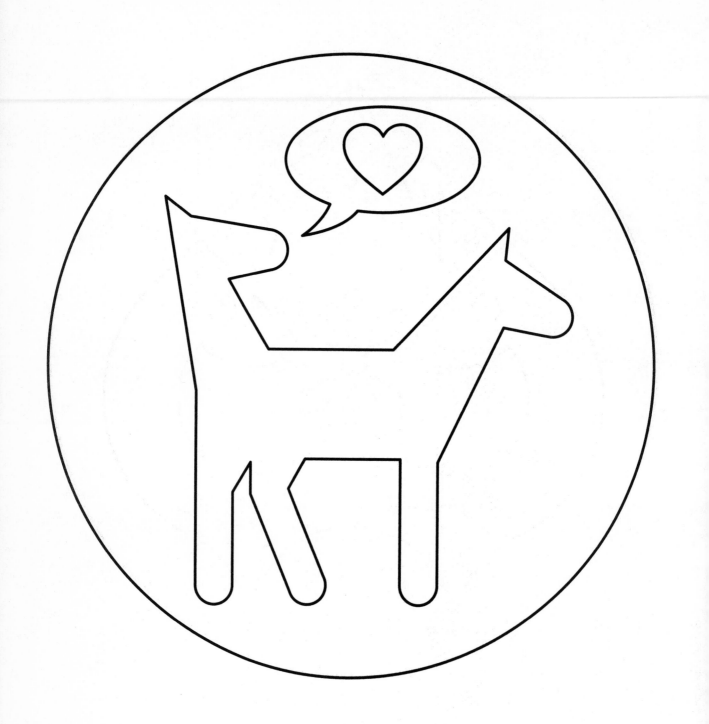

Ryan McGinness

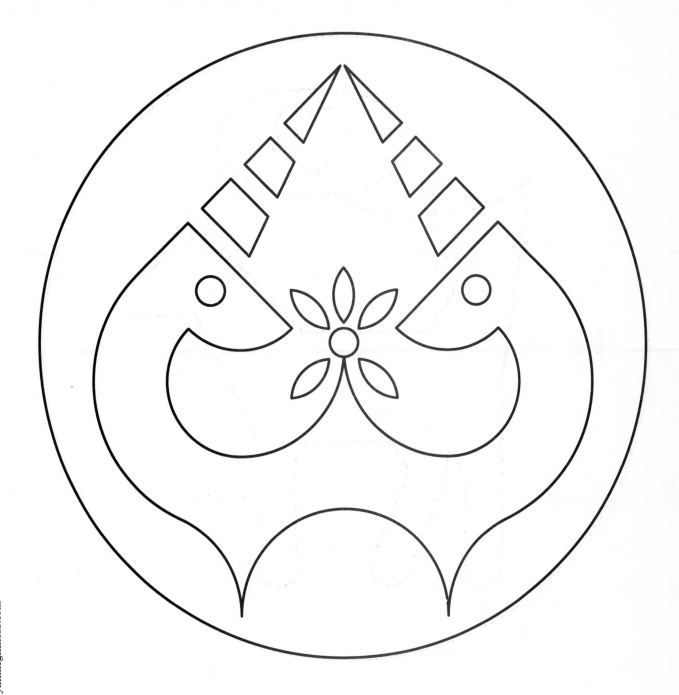

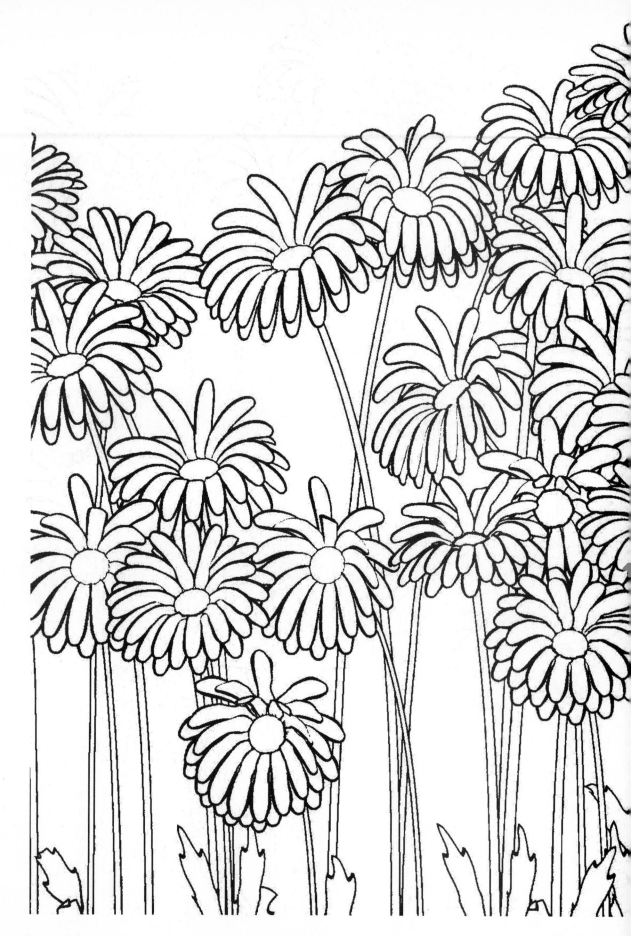

Jennifer Steinkamp

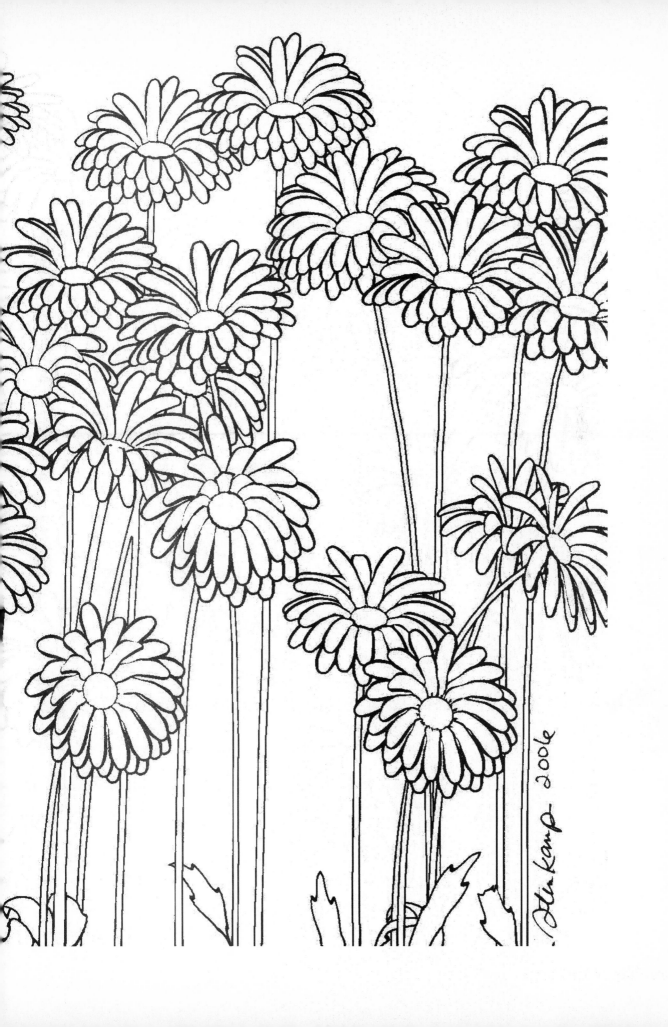

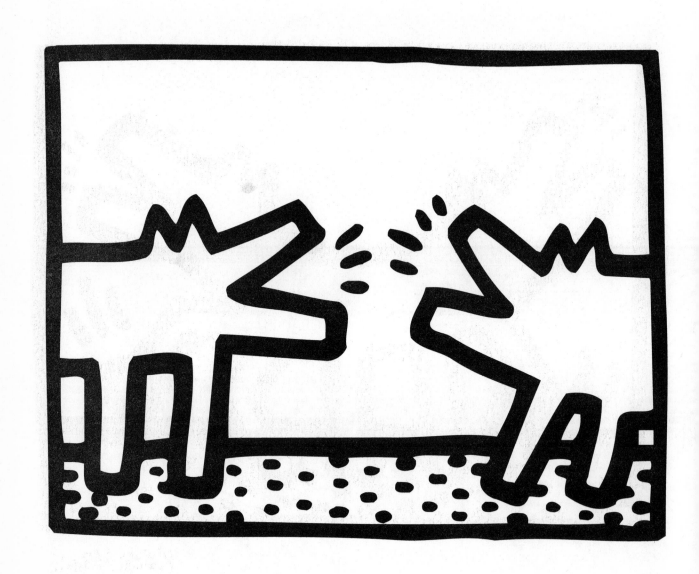

Keith Haring

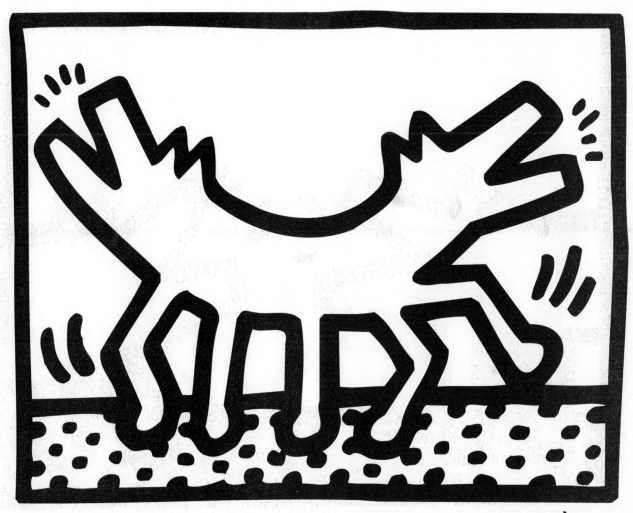

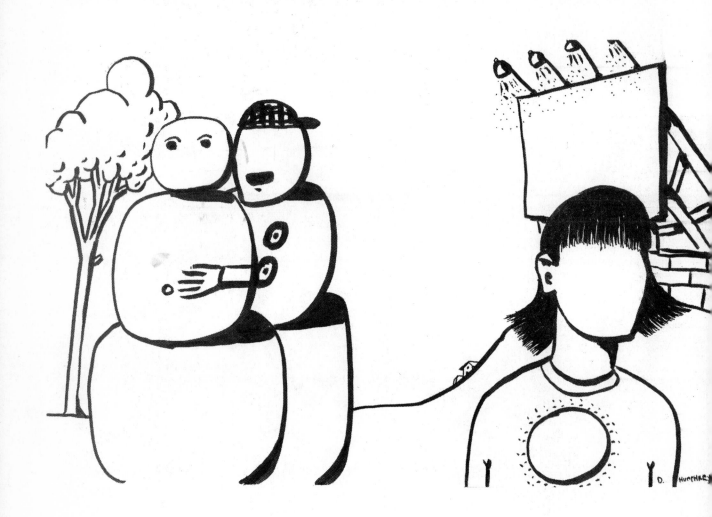

David Humphrey

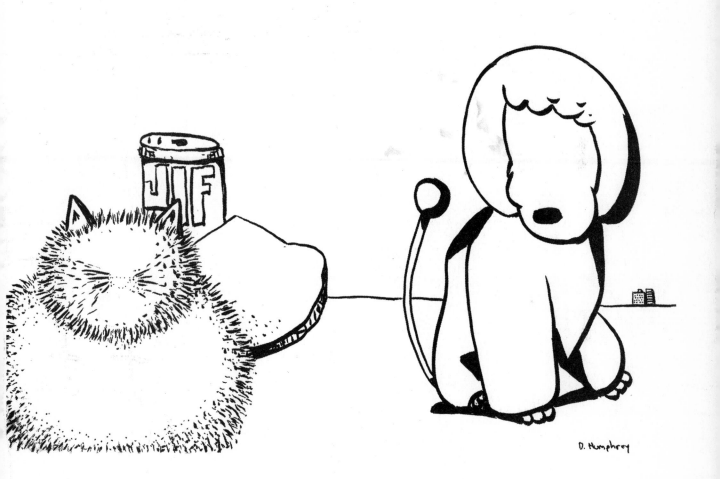

Neil Jenney

FELON 2 '97 *my mk.*

Ed Baynard

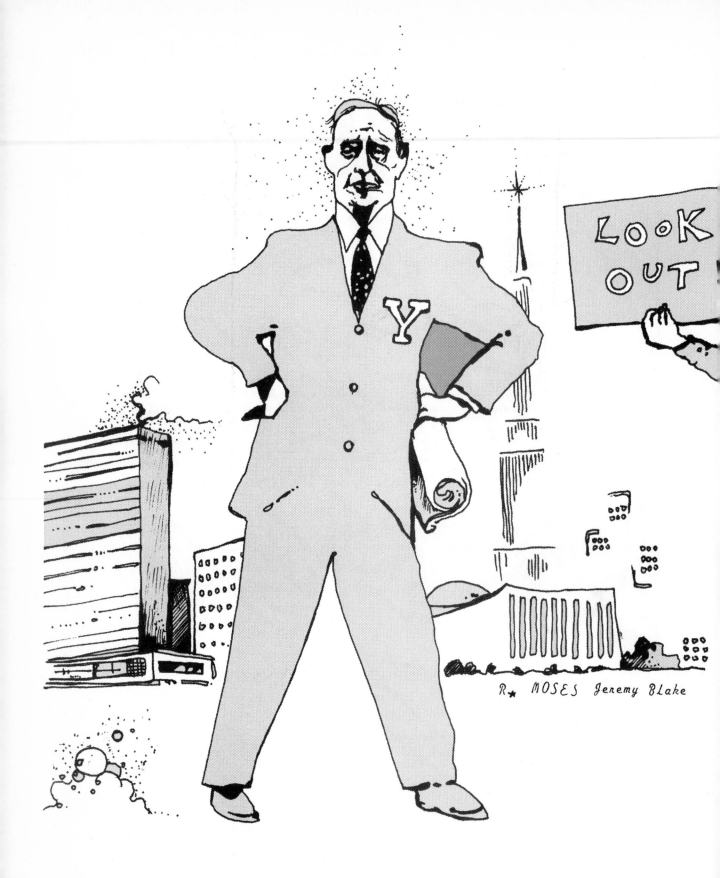

Jeremy Blake

Falling Water?

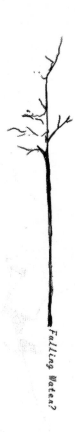

Falling Water?

Try Falling Everything.

Leo Villareal

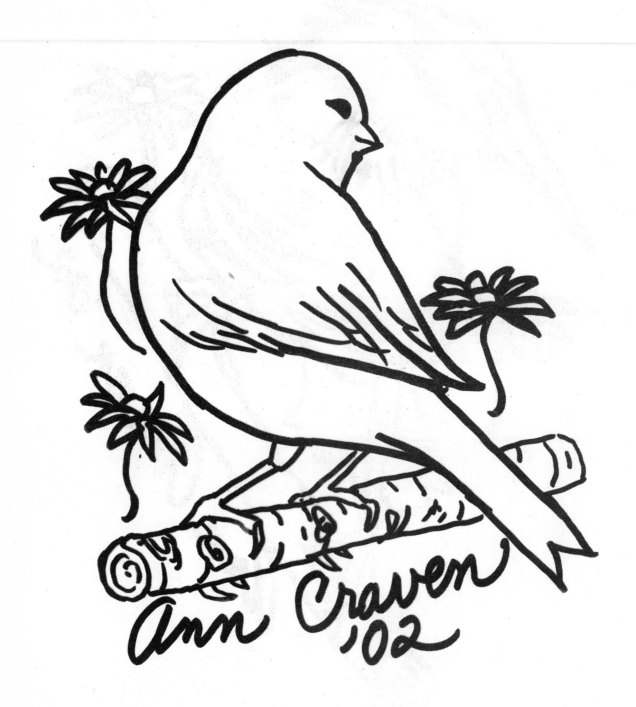

Ann Craven

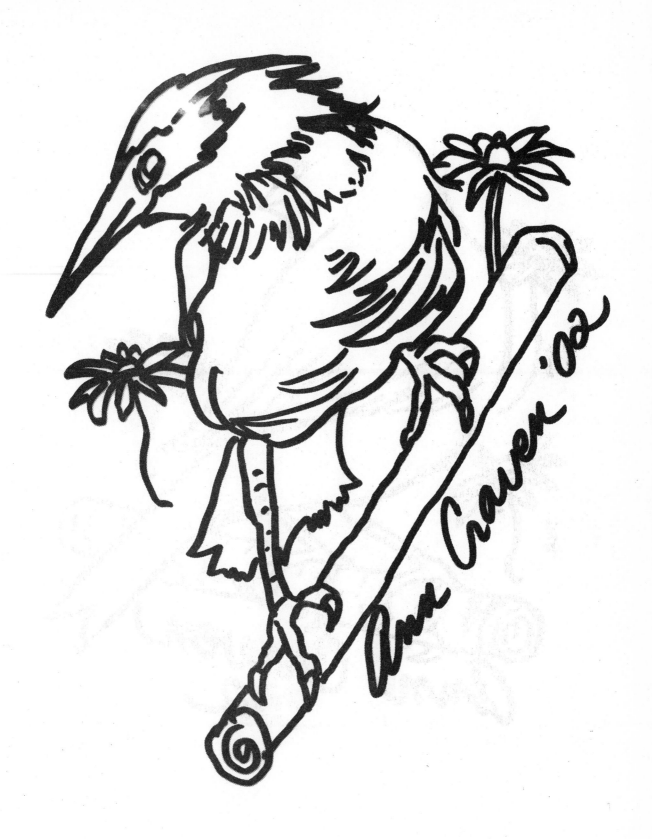

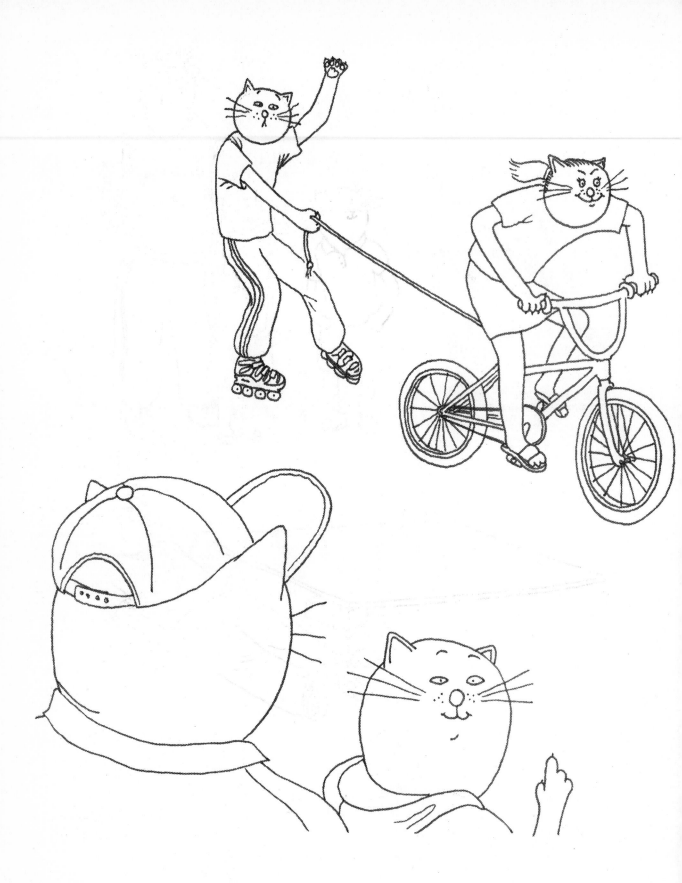

Jim Medway

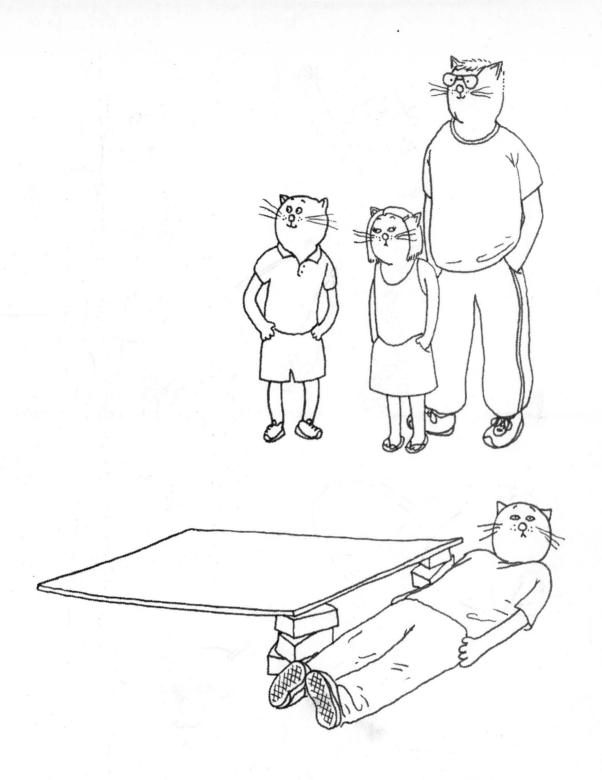

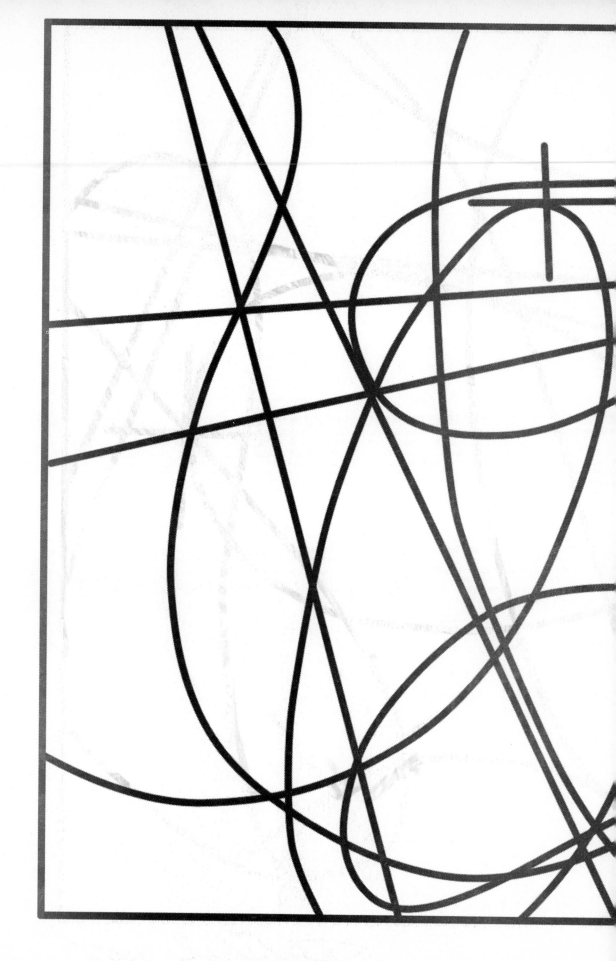

David Row

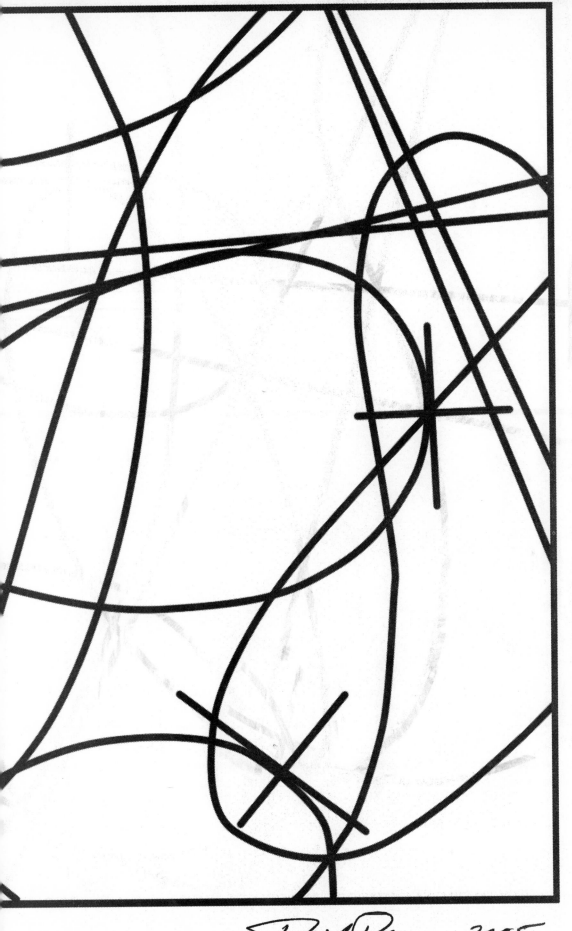

David Row 2005

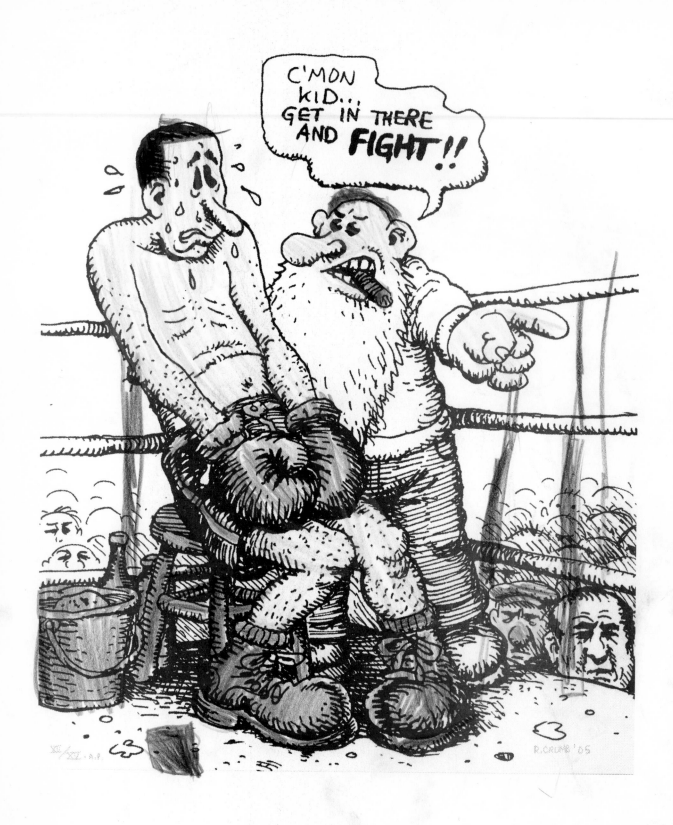

R. Crumb

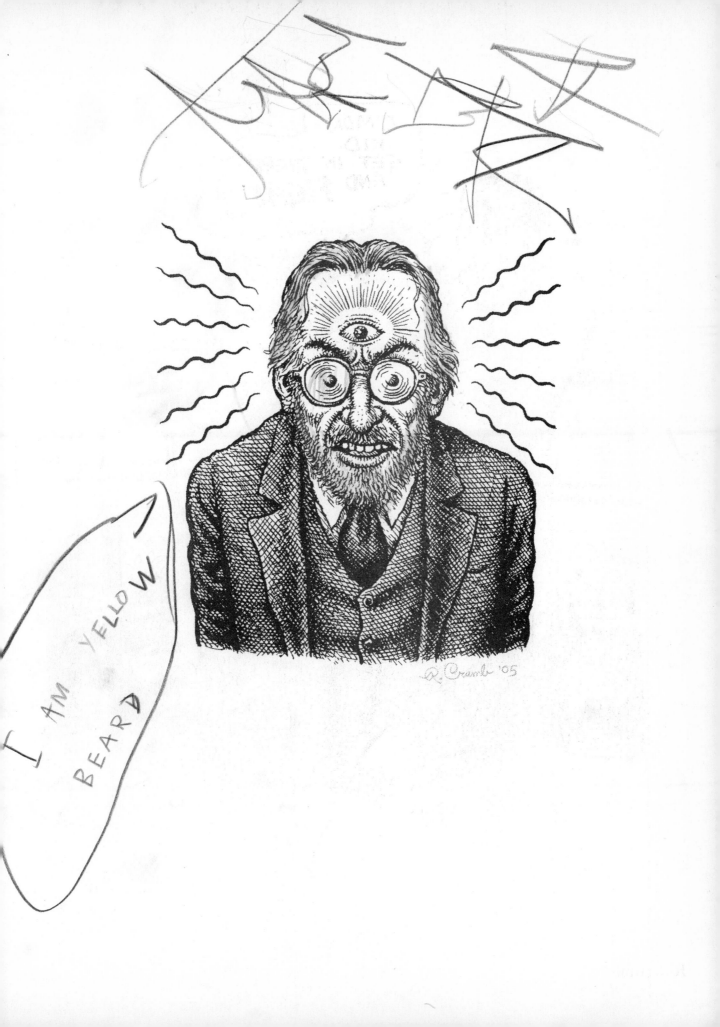

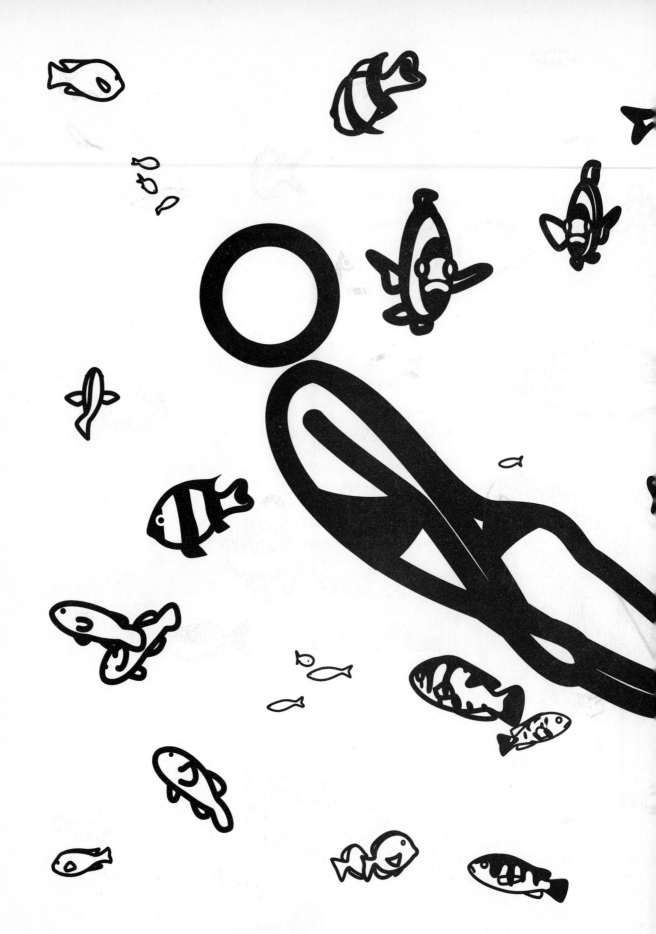

Julian Opie

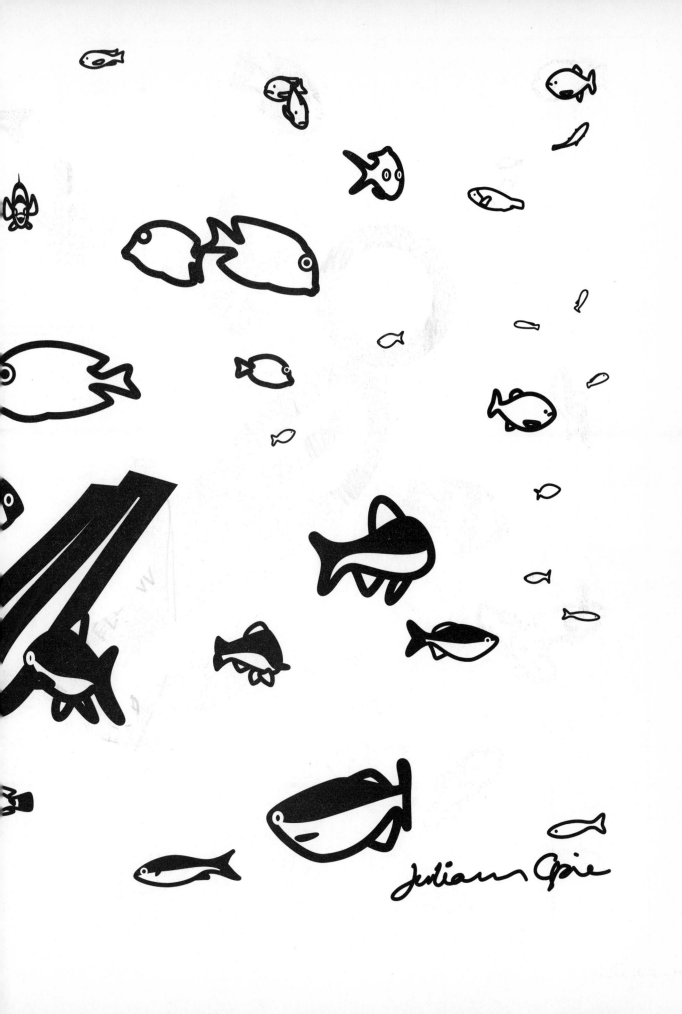

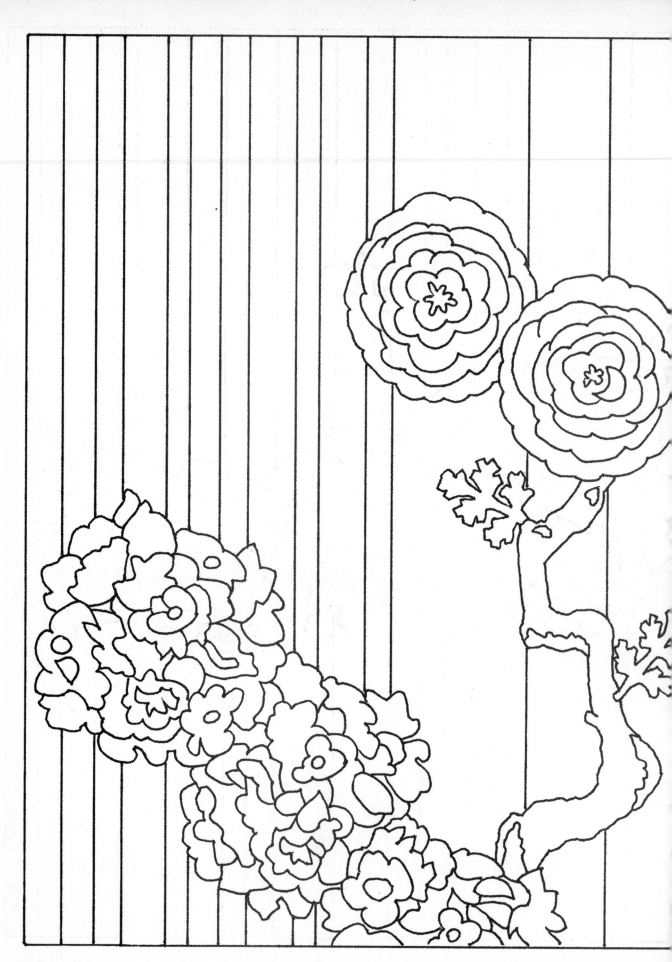

Virgil Marti

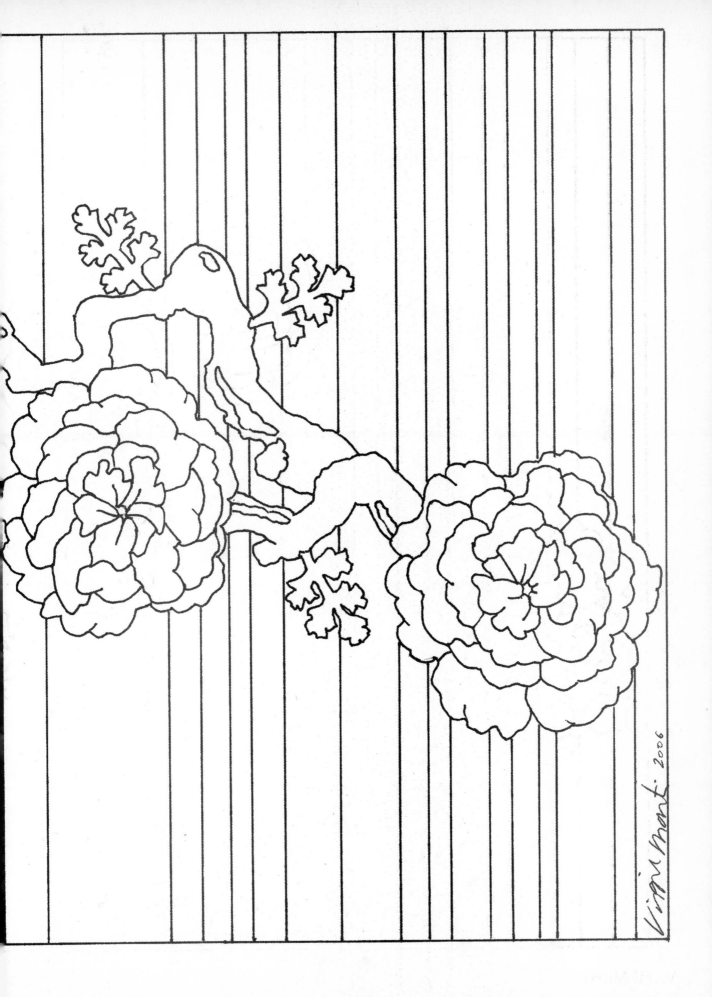

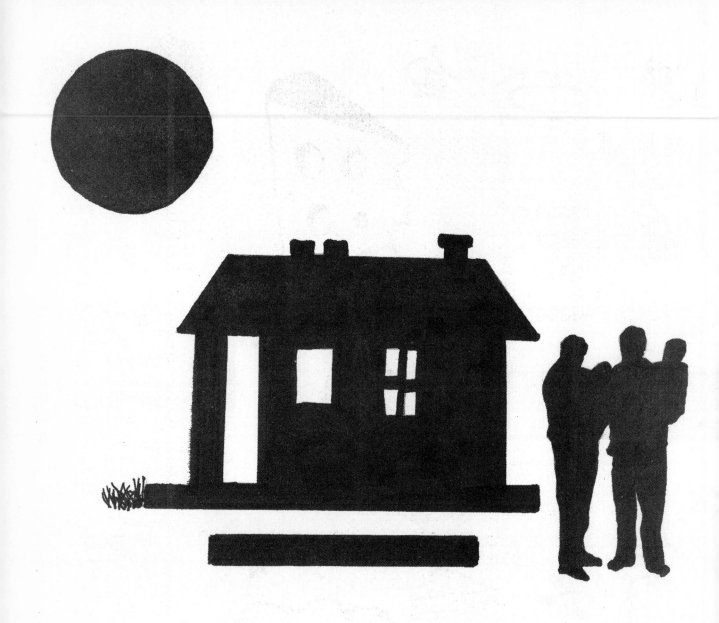

DGRANT 2006

Deborah Grant

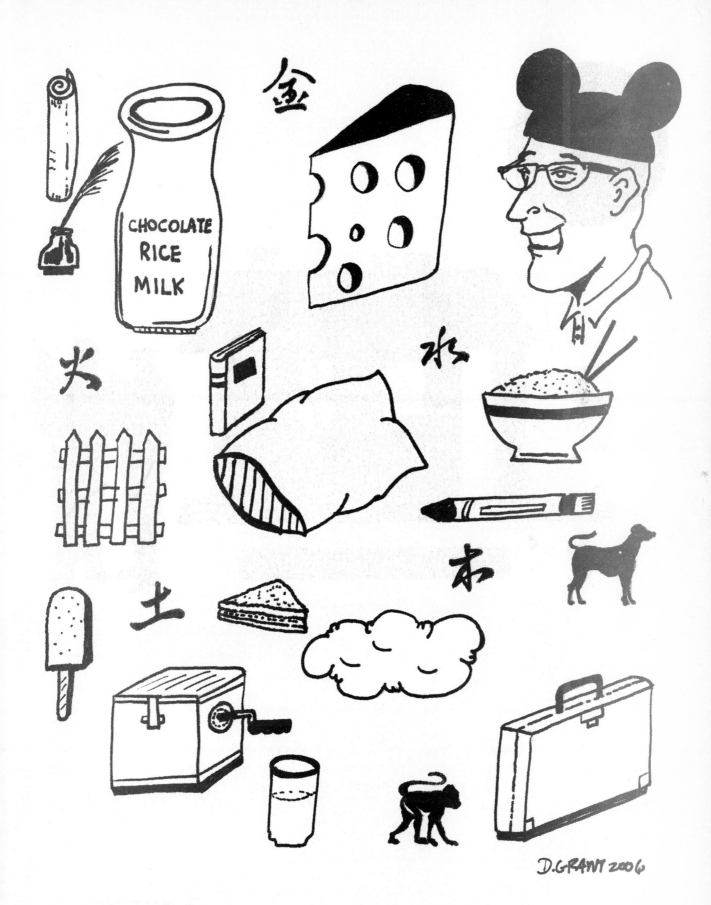

CHOCOLATE RICE MILK

金

水

木

火

土

D.GRANT 2006

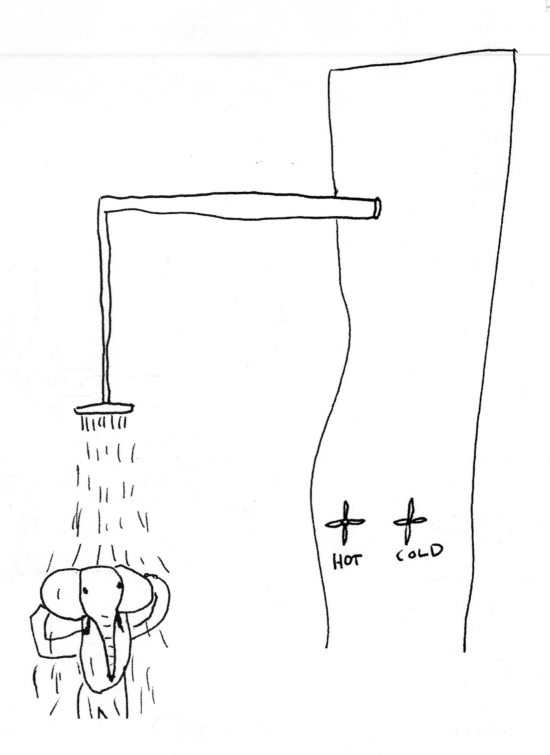

John Lurie

Ryan McGinness

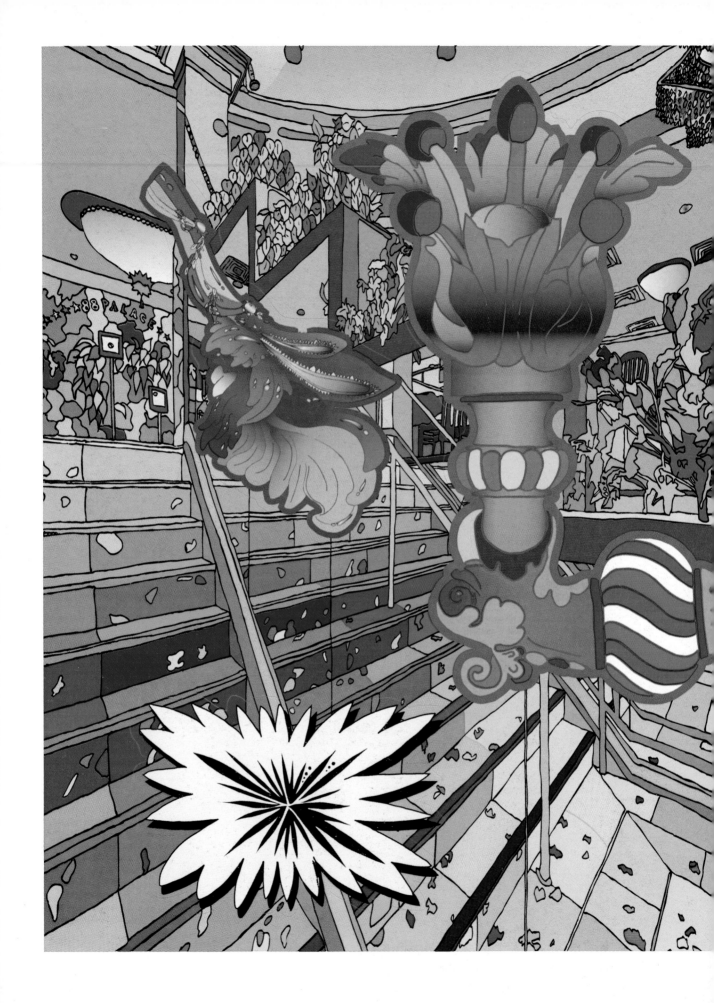

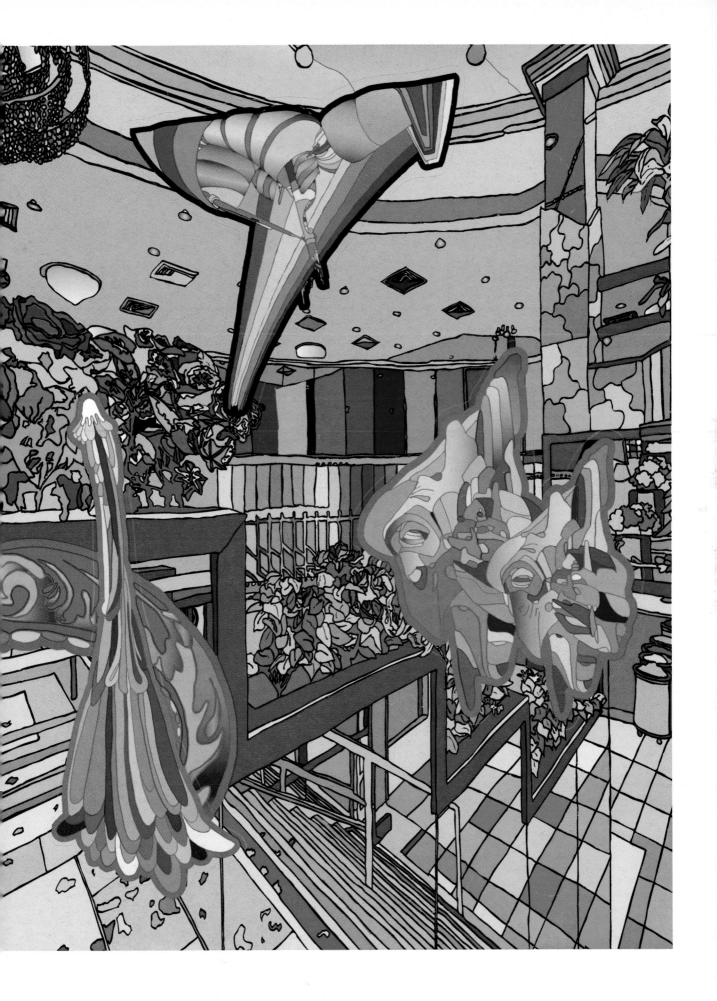

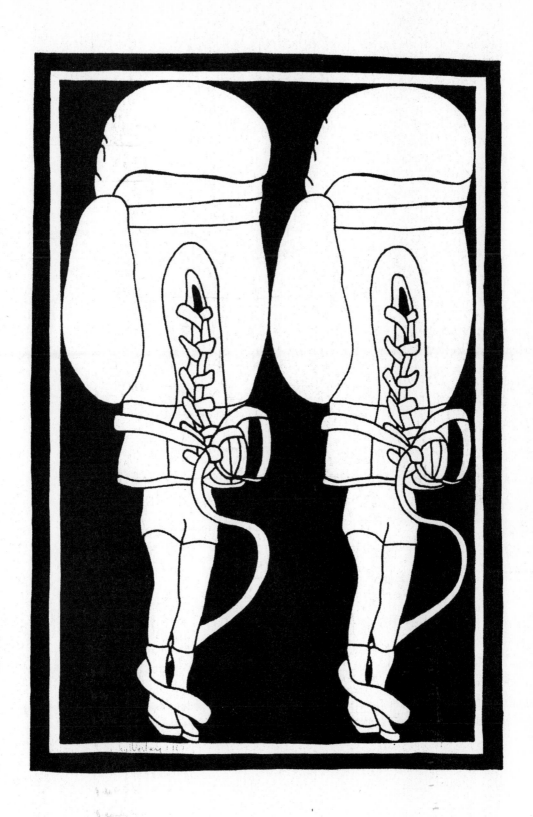

John Wesley

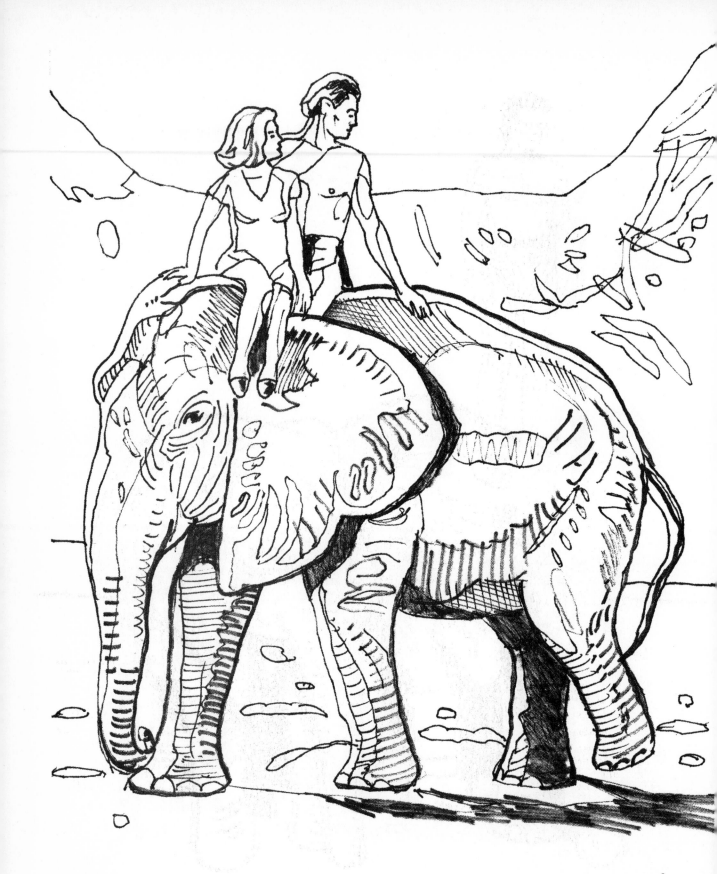

TARZAN + JANE IN AFRICA Duncan Hannah

Duncan Hannah

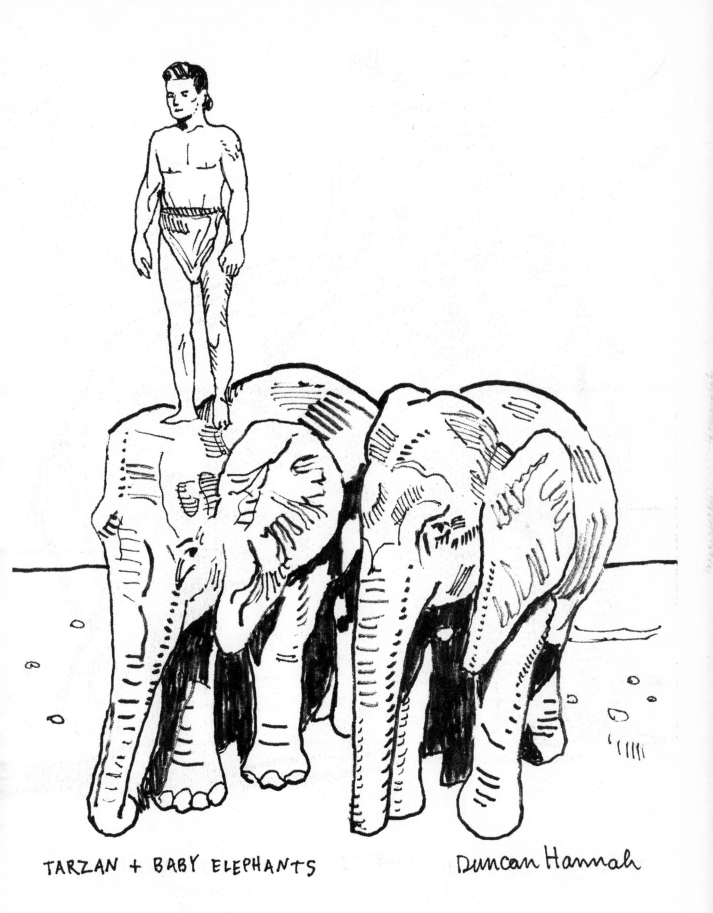

TARZAN + BABY ELEPHANTS Duncan Hannah

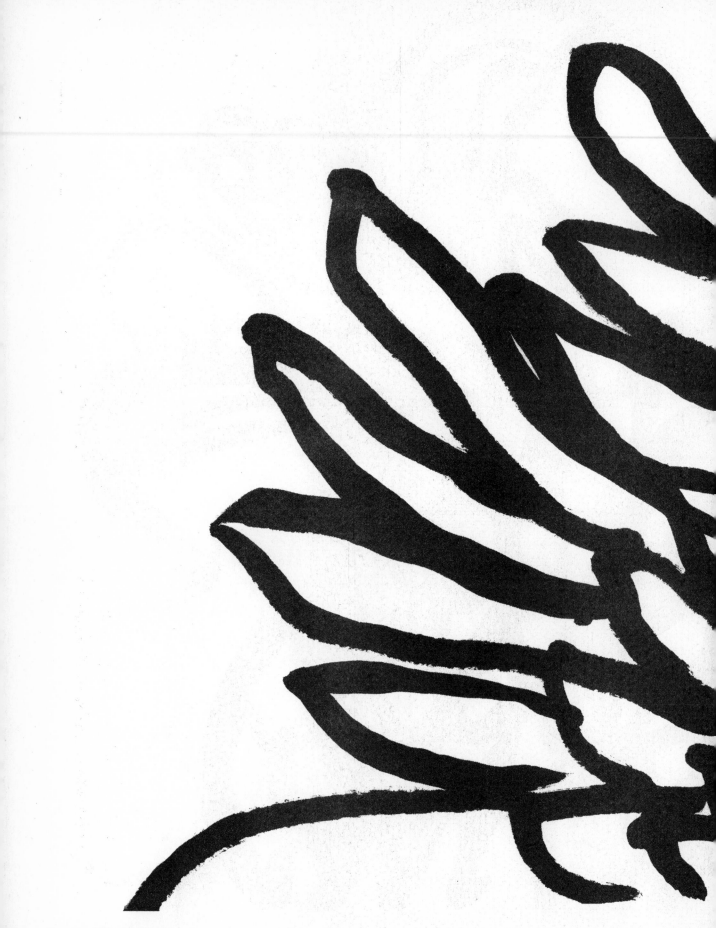

Grace Hartigan

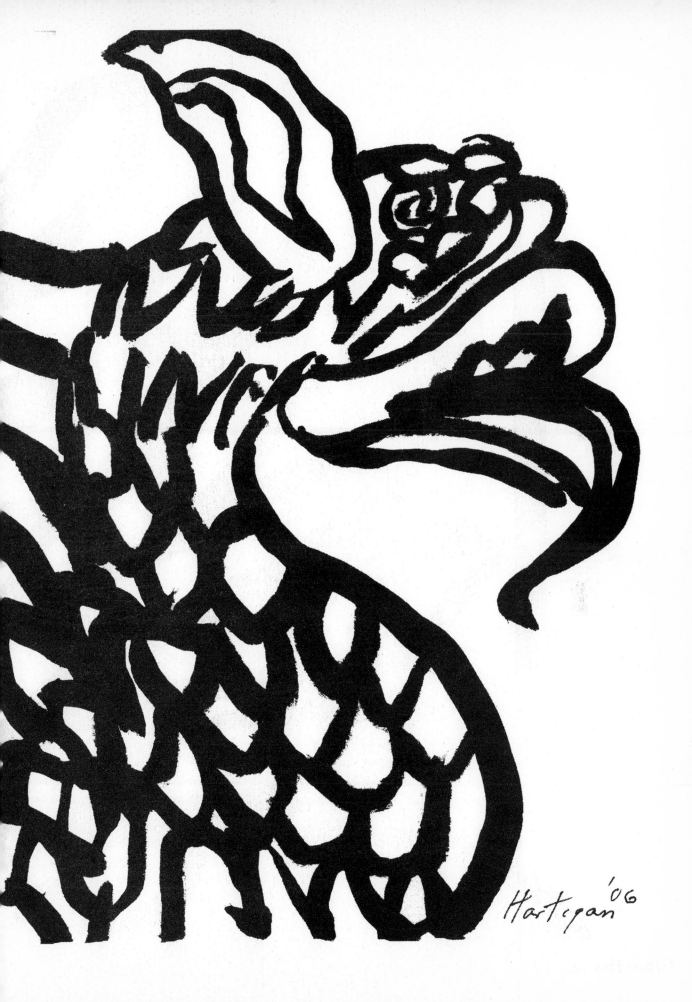

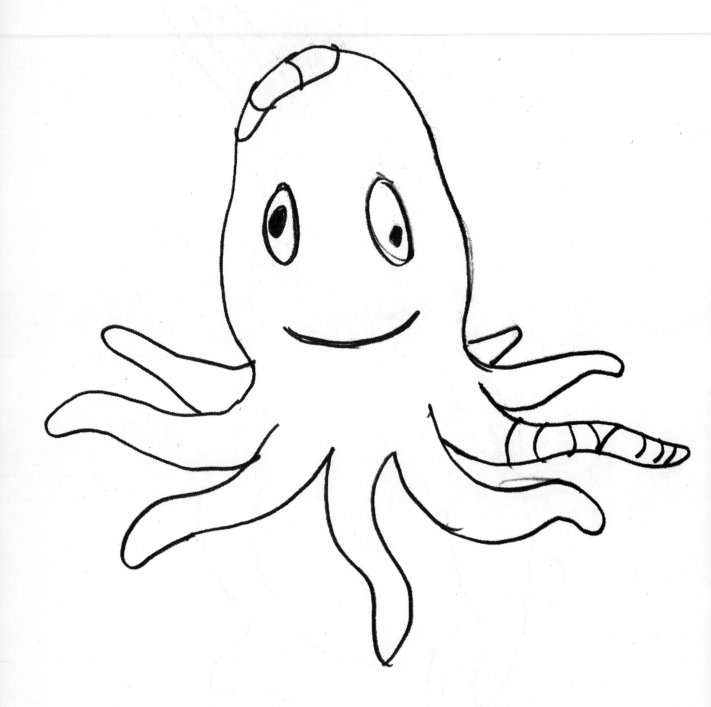

Tom Otterness

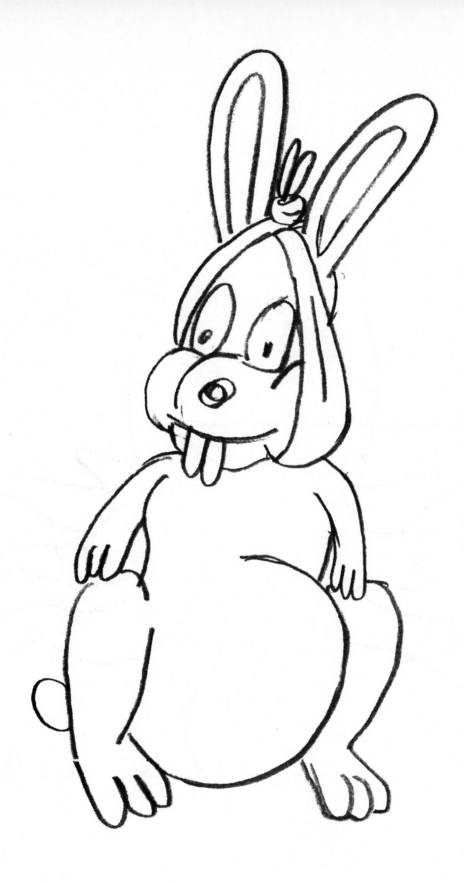

Tom Otterness

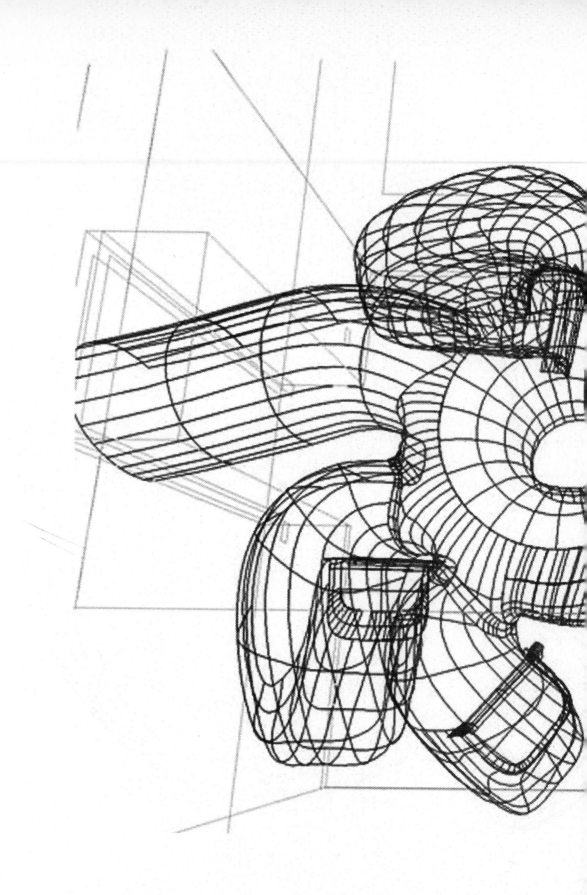

Vito Acconci

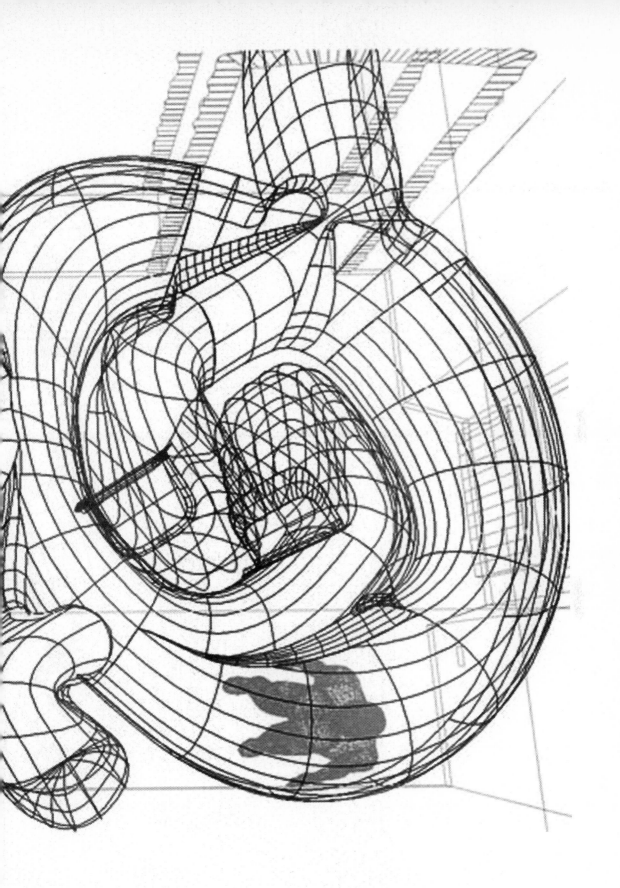

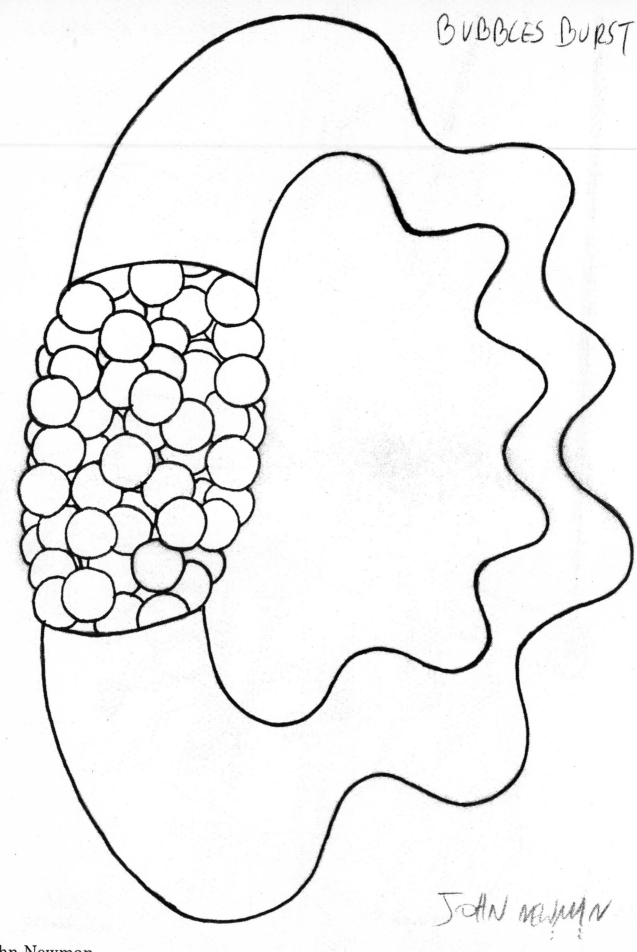

BUBBLES BURST

John Newman

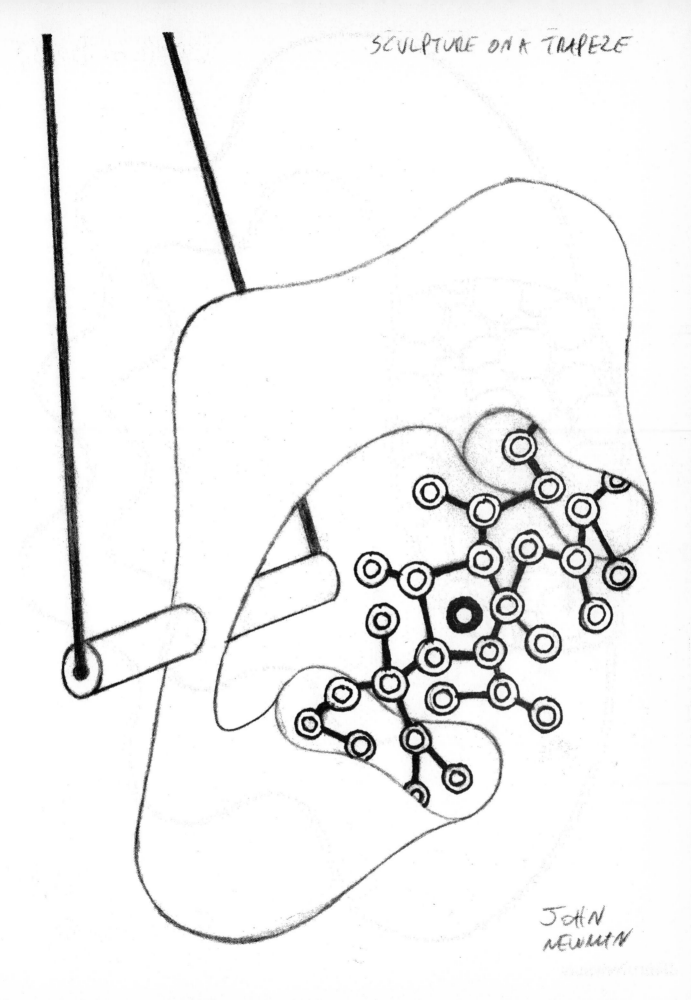

SCULPTURE ON A TRAPEZE

JOHN
NEWMAN

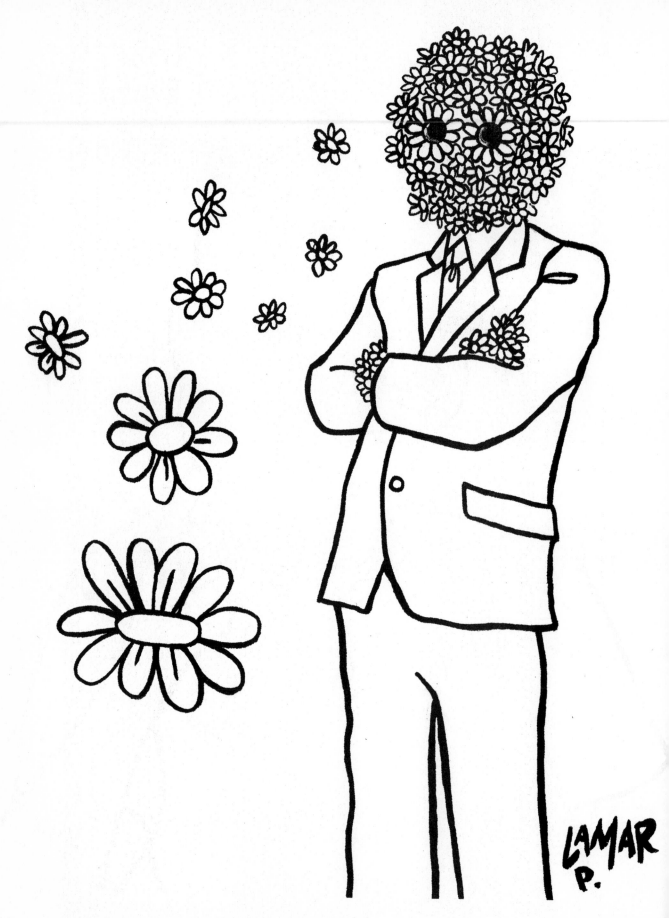

Lamar Peterson

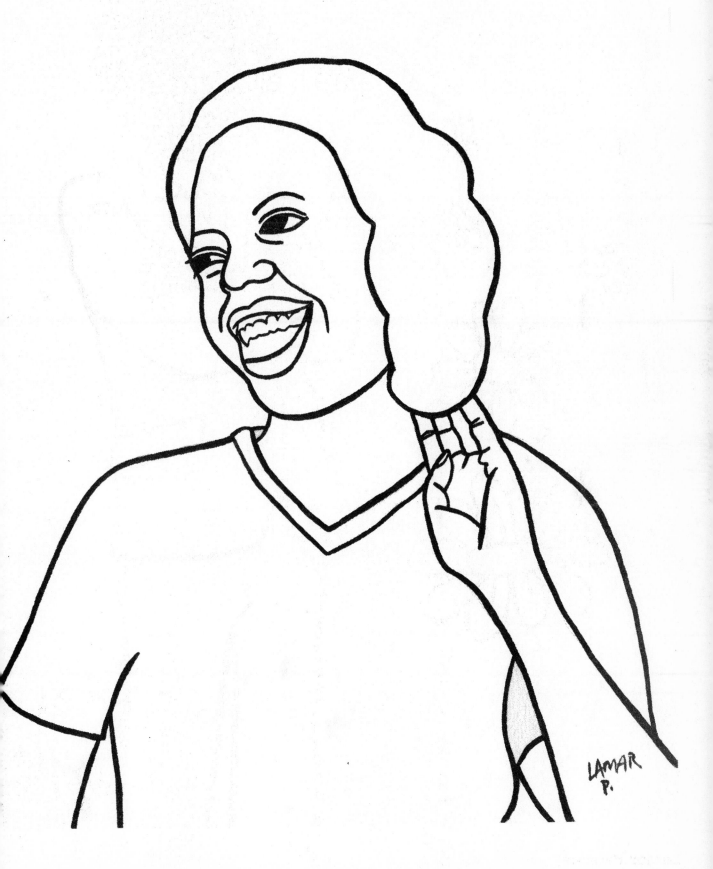

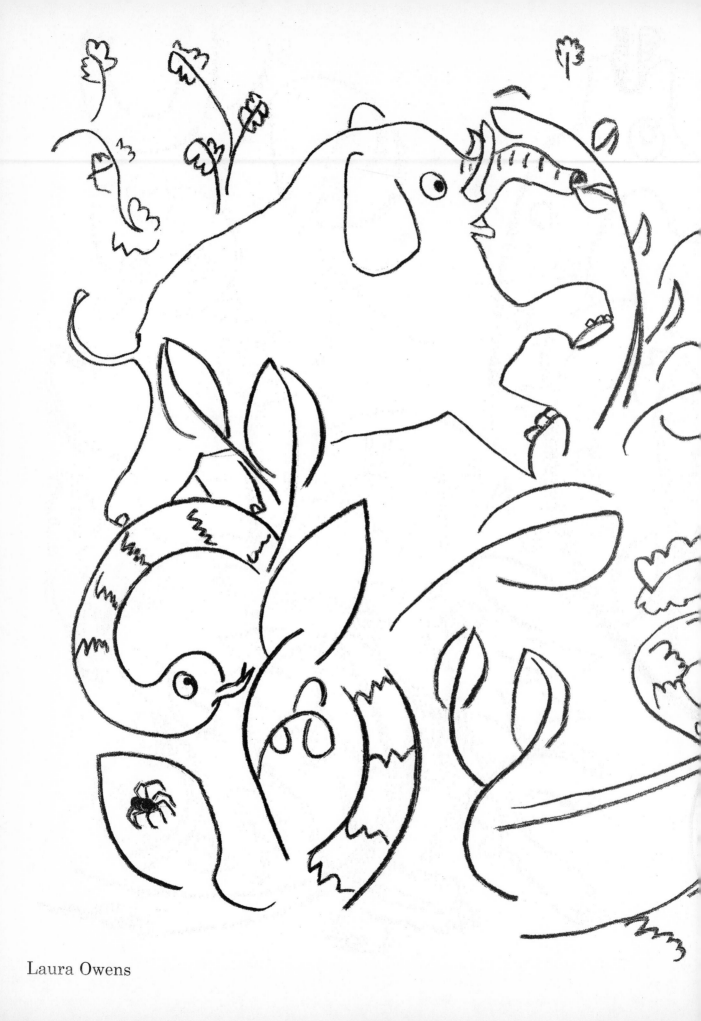

Laura Owens

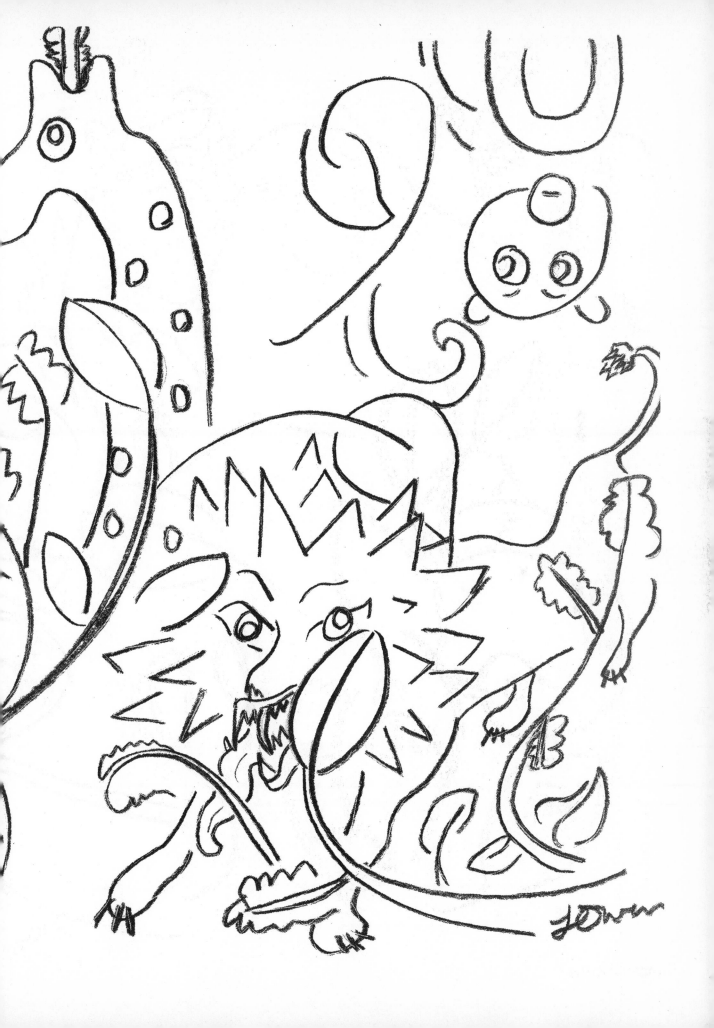

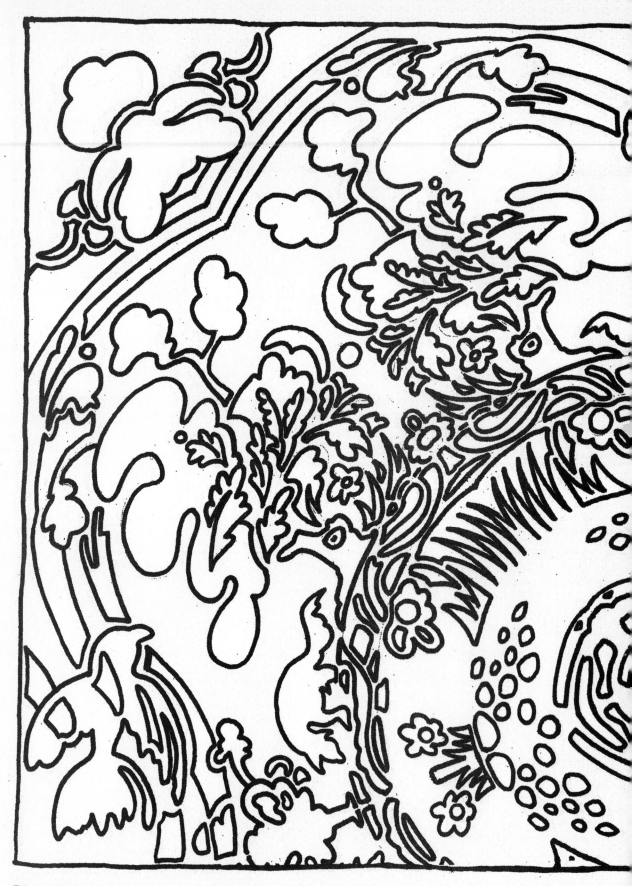

Your Name _____

Lane Twitchell

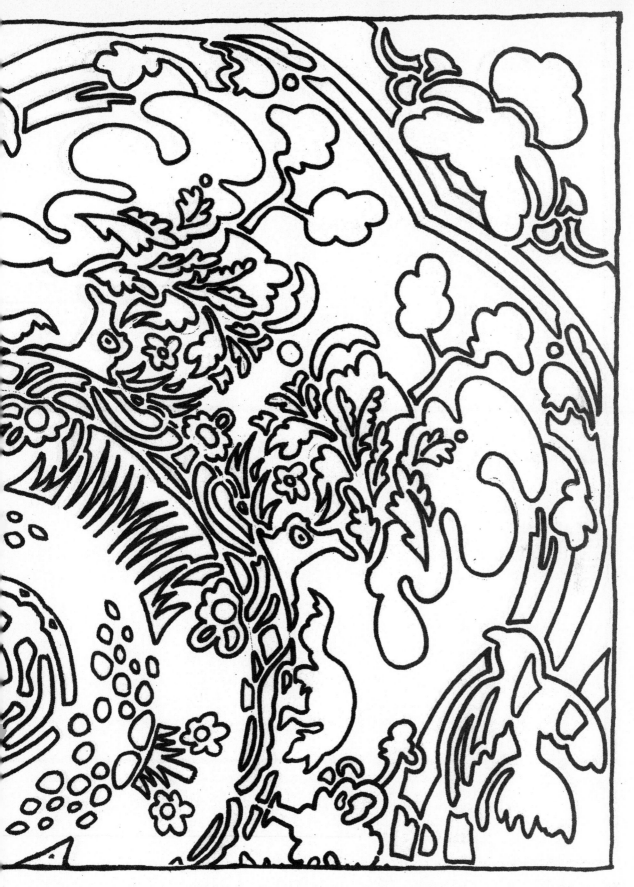

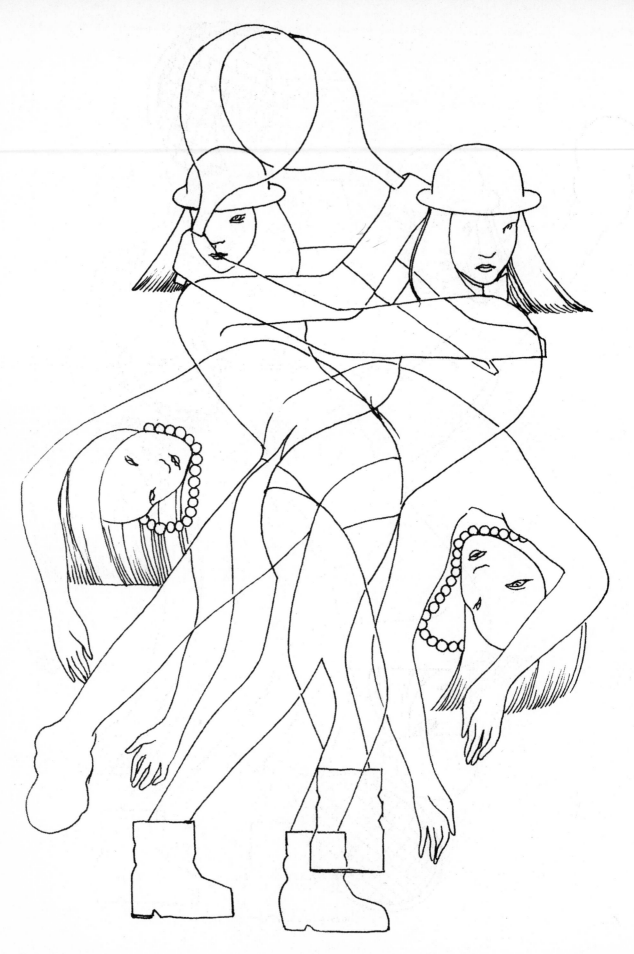

Rita Ackermann

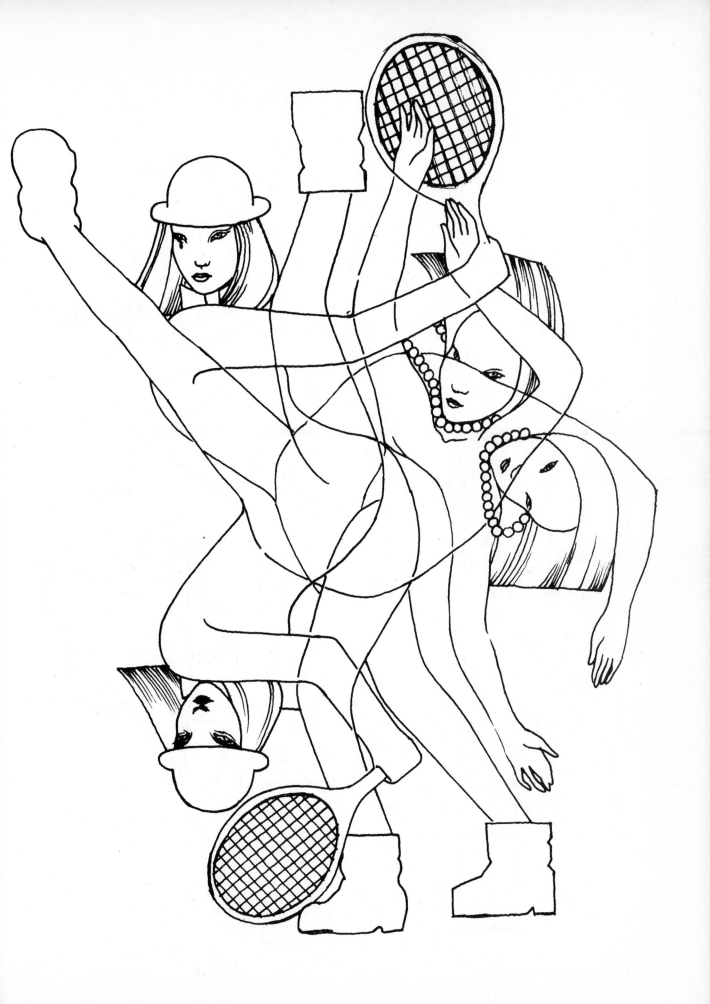

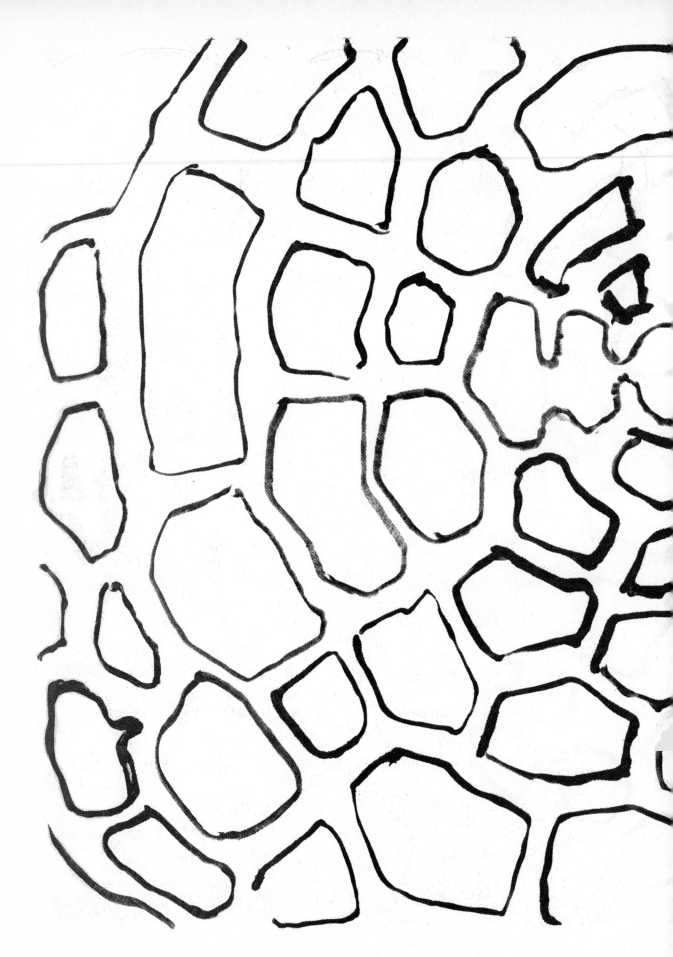

Michele Oka Doner

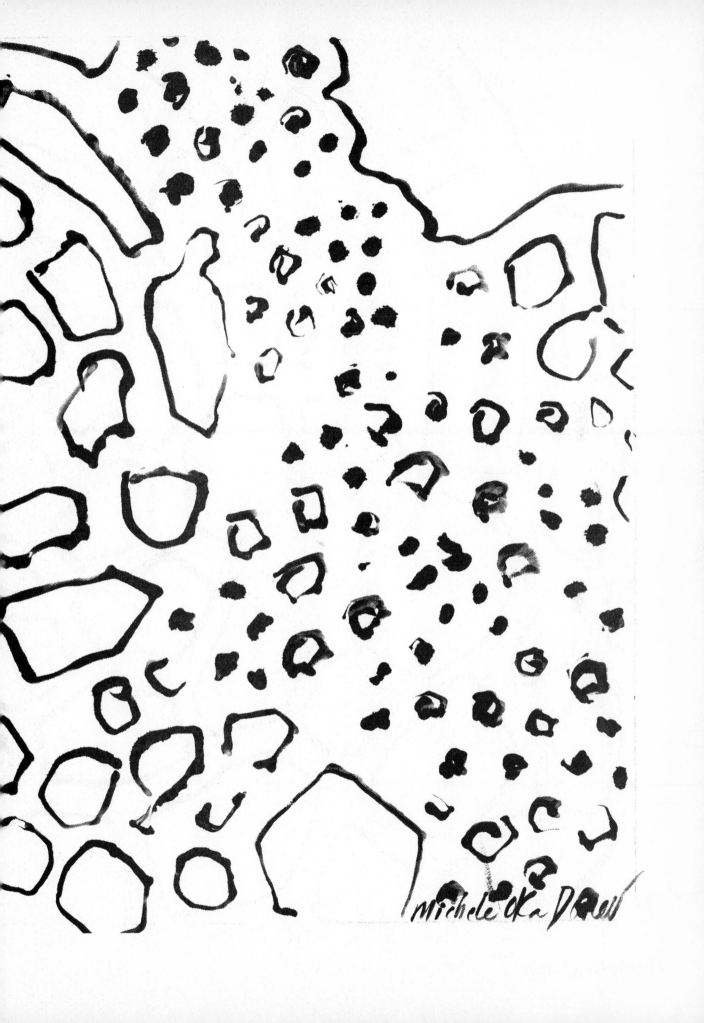

Michele Oka Doner

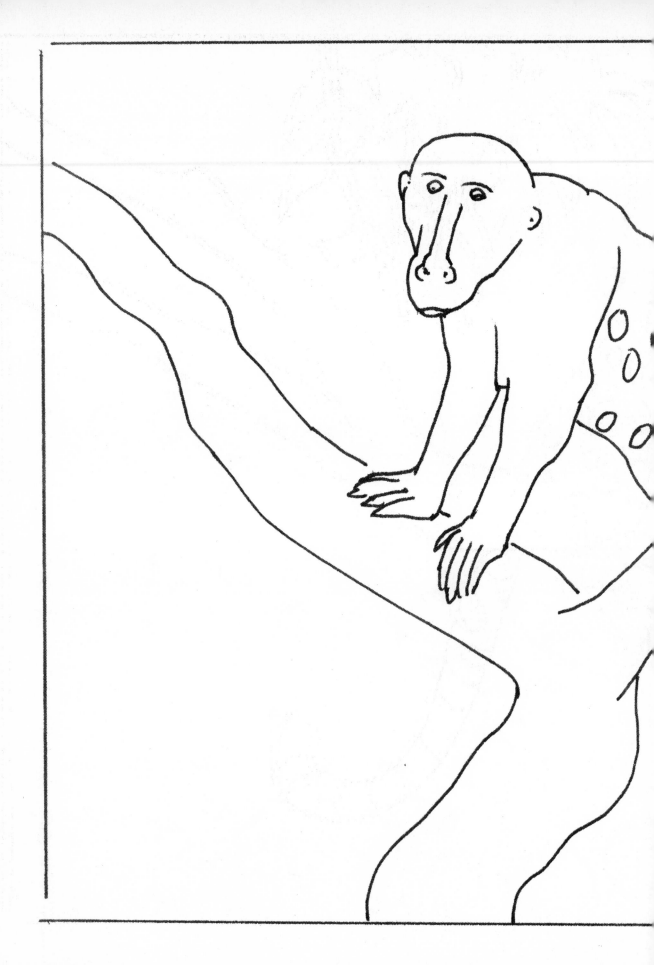

Alexis Rockman

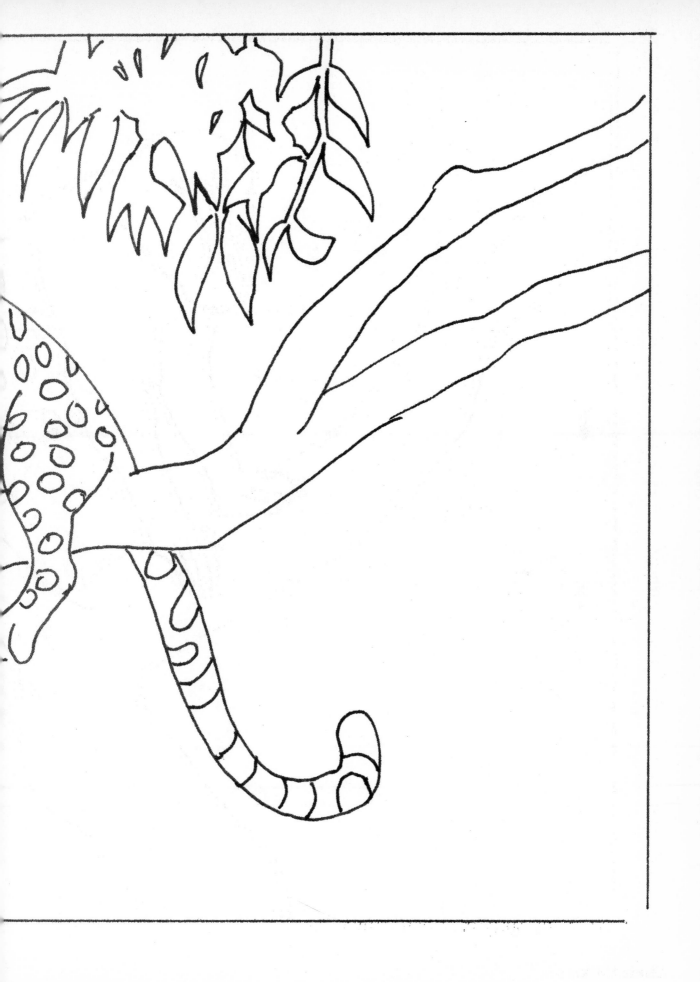

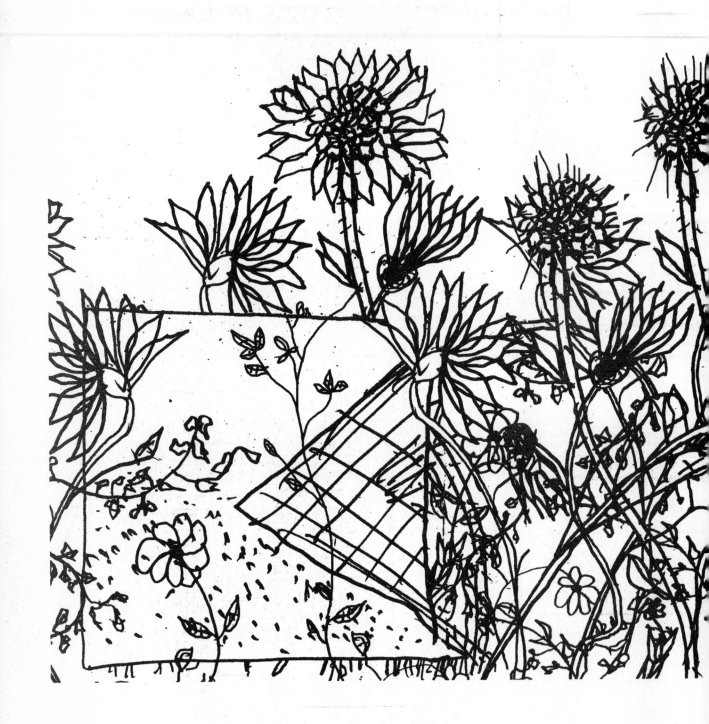

Chris Astley

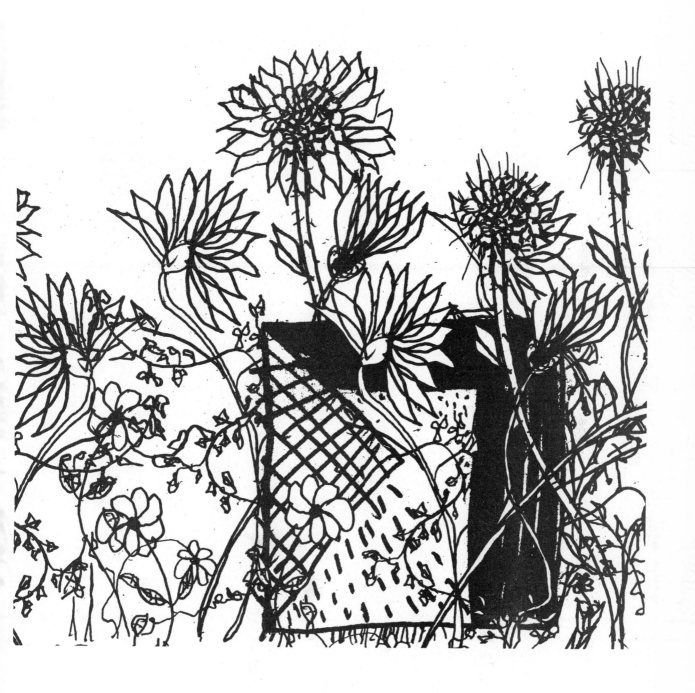

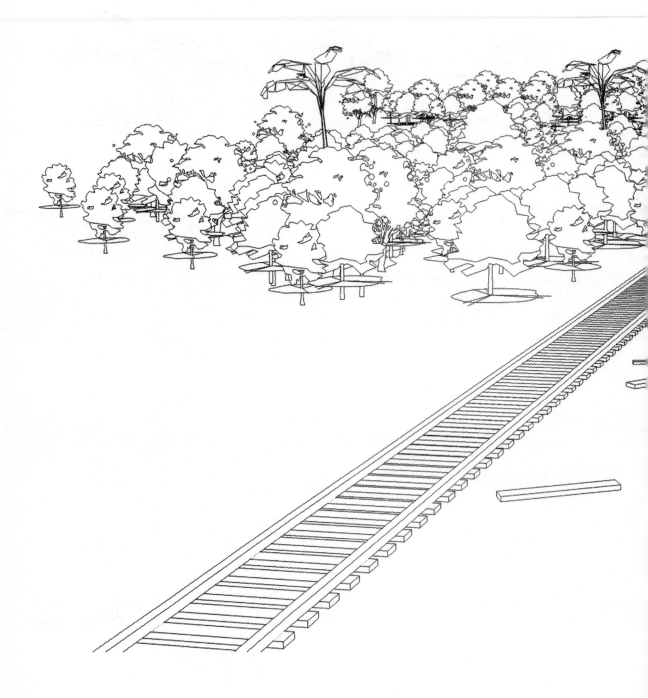

Graham Parker

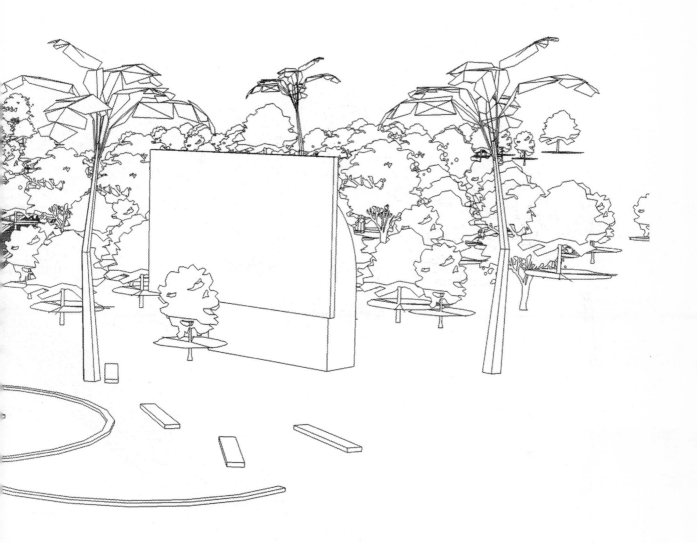

Graham Parker

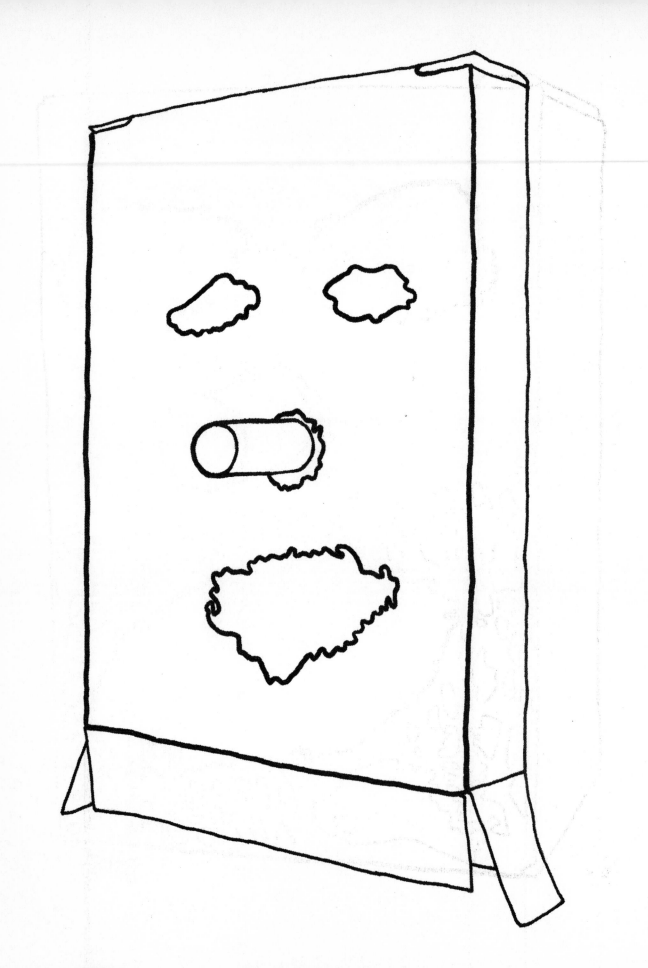

Mark Grotjahn

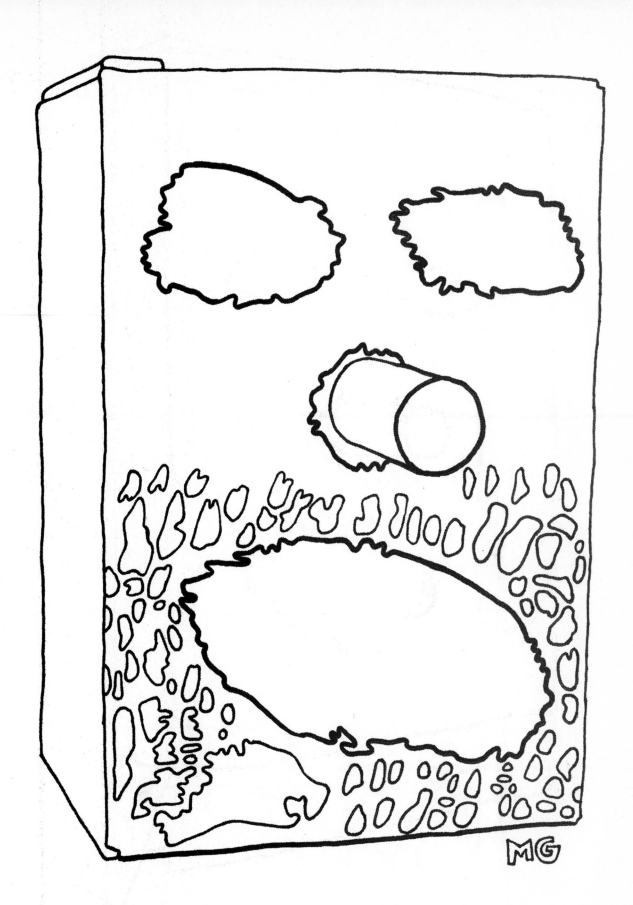

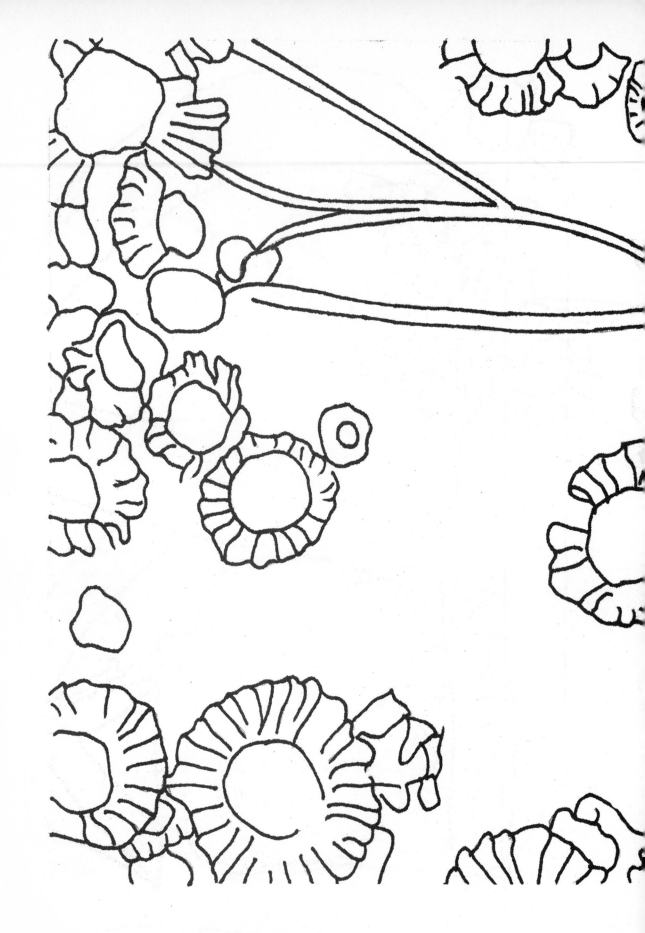

Gary Hume

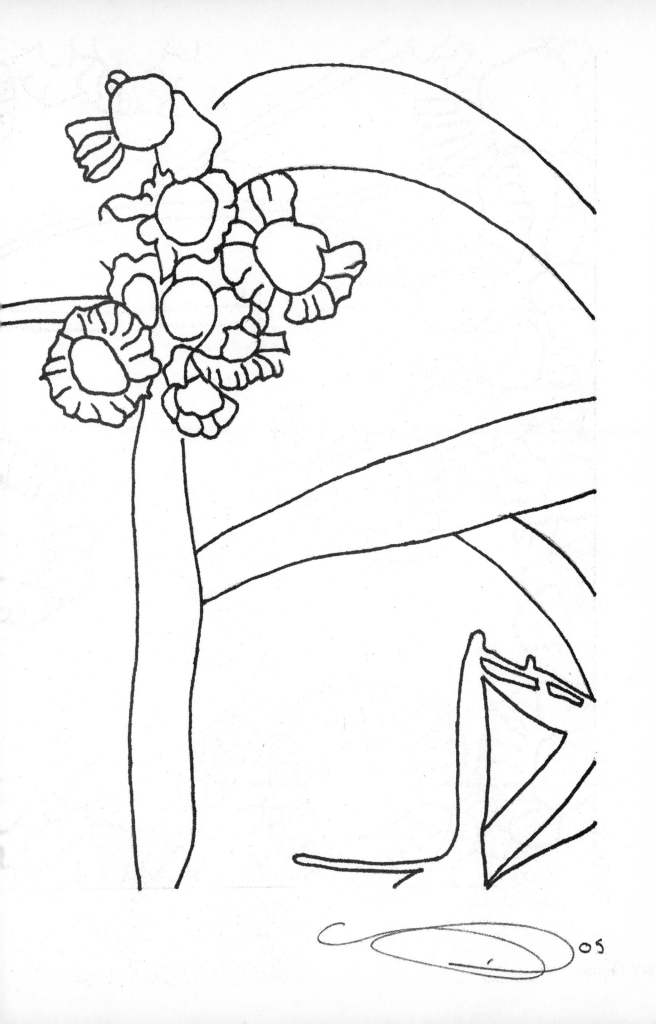

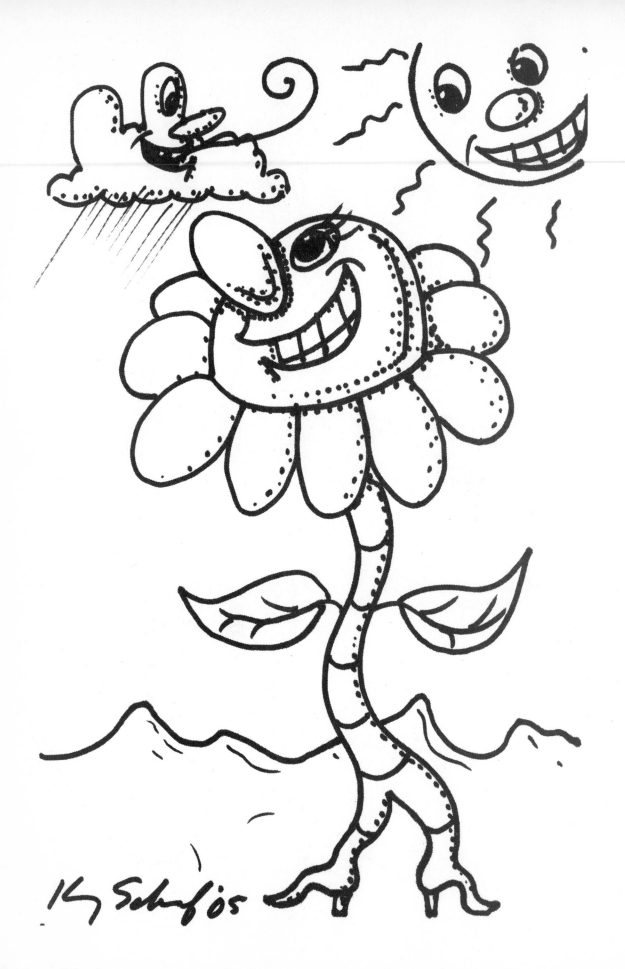

Kenny Scharf

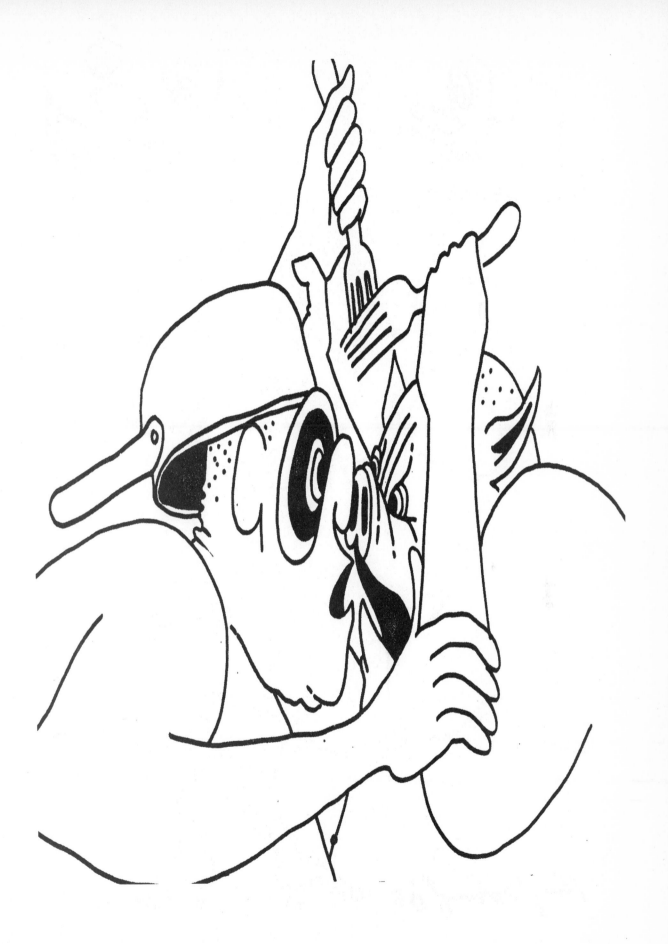

Willie Cole

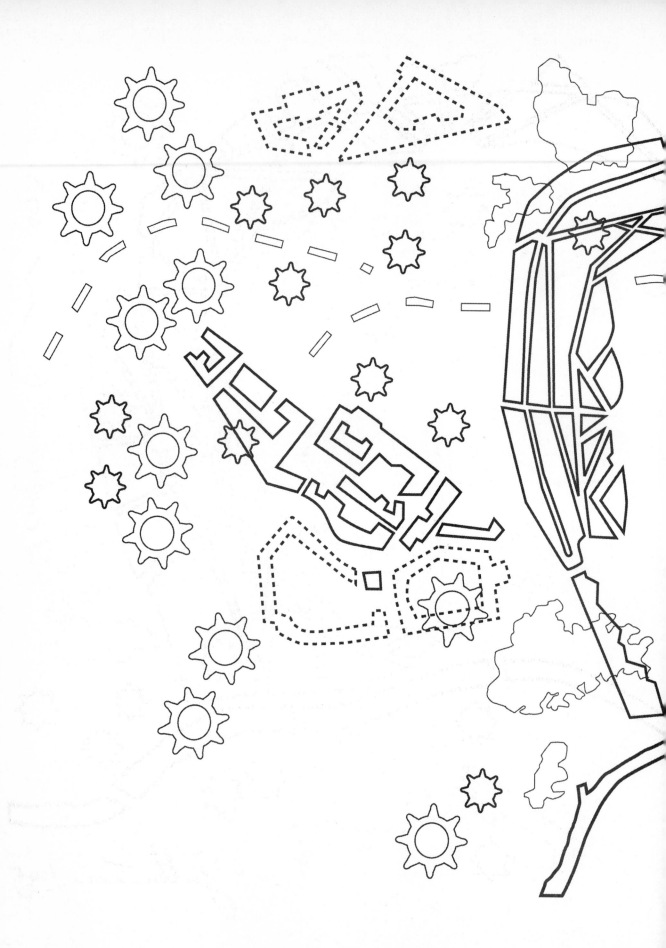

Geraldine Lau

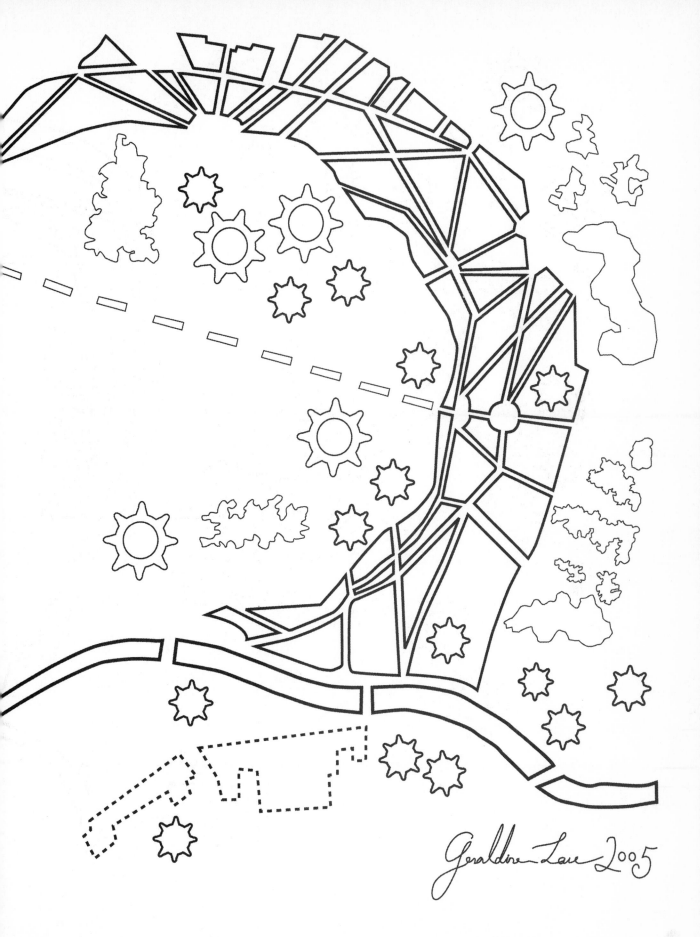

Geraldine Lau 2005

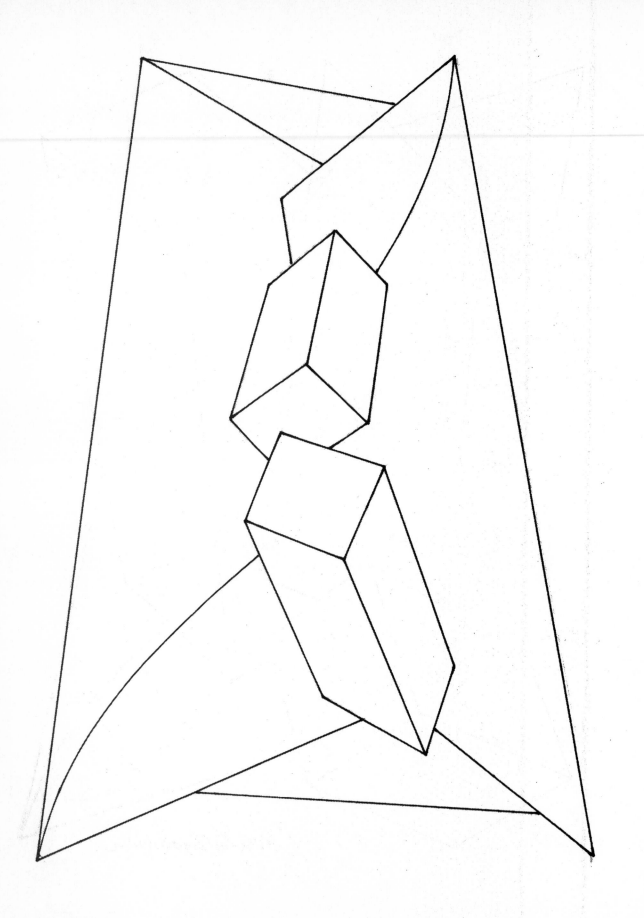

Charles Hinman

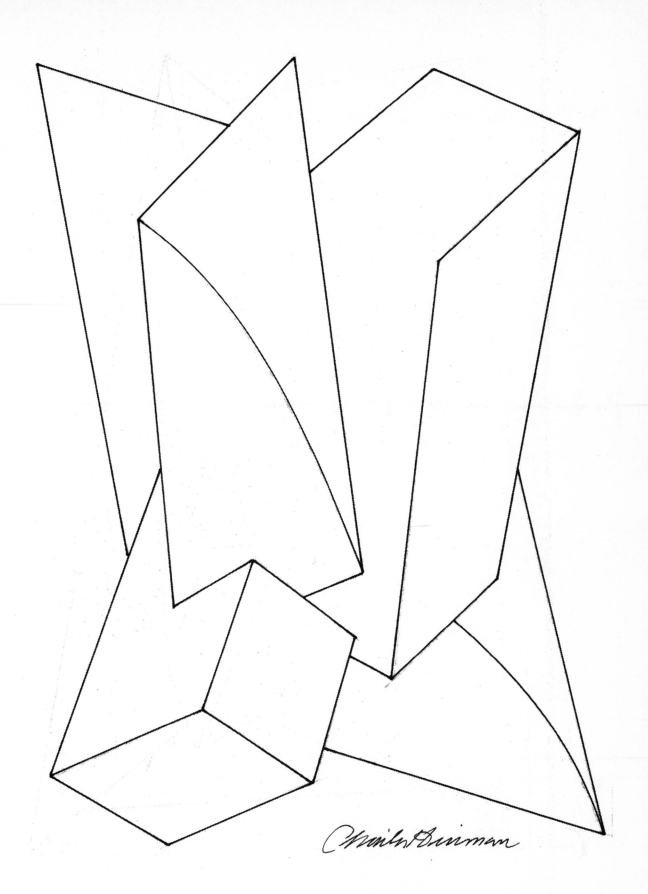

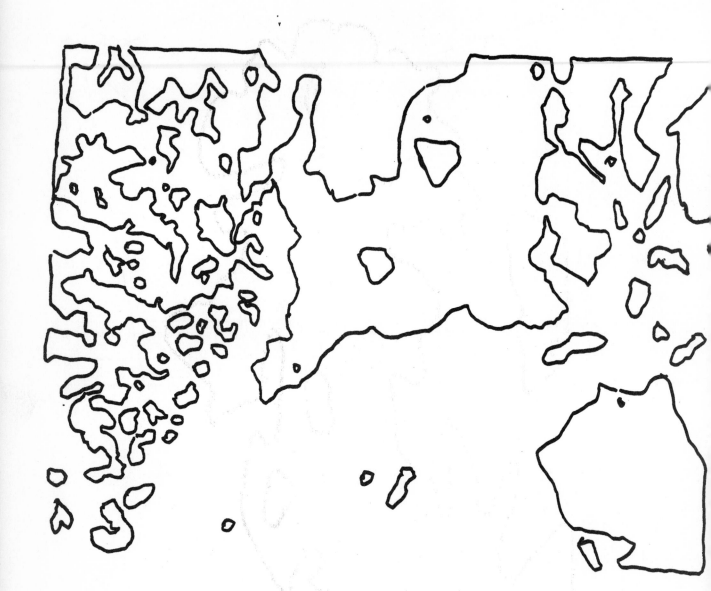

Joel Fisher

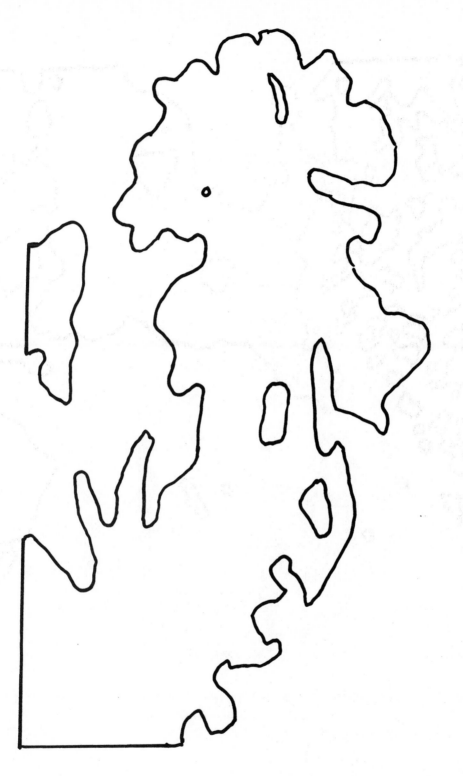

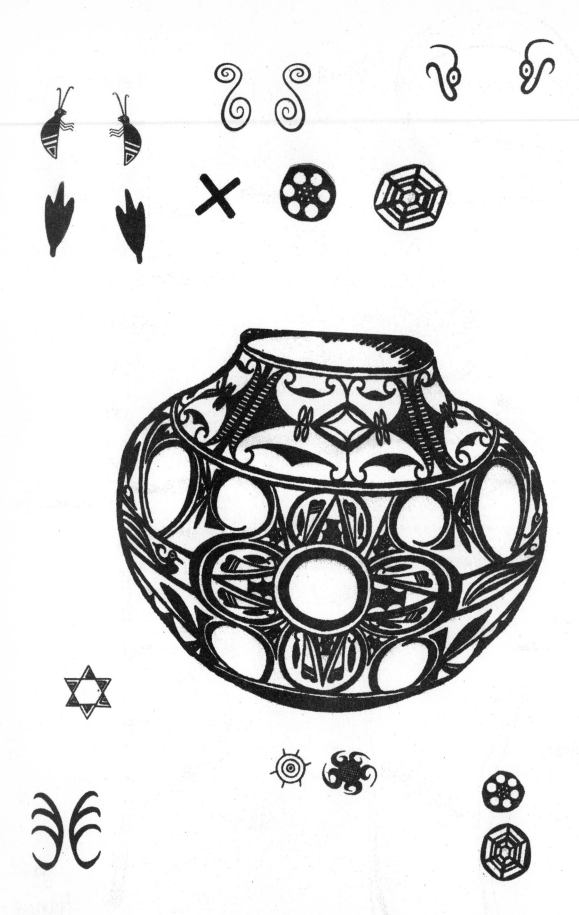

Jane Hammond

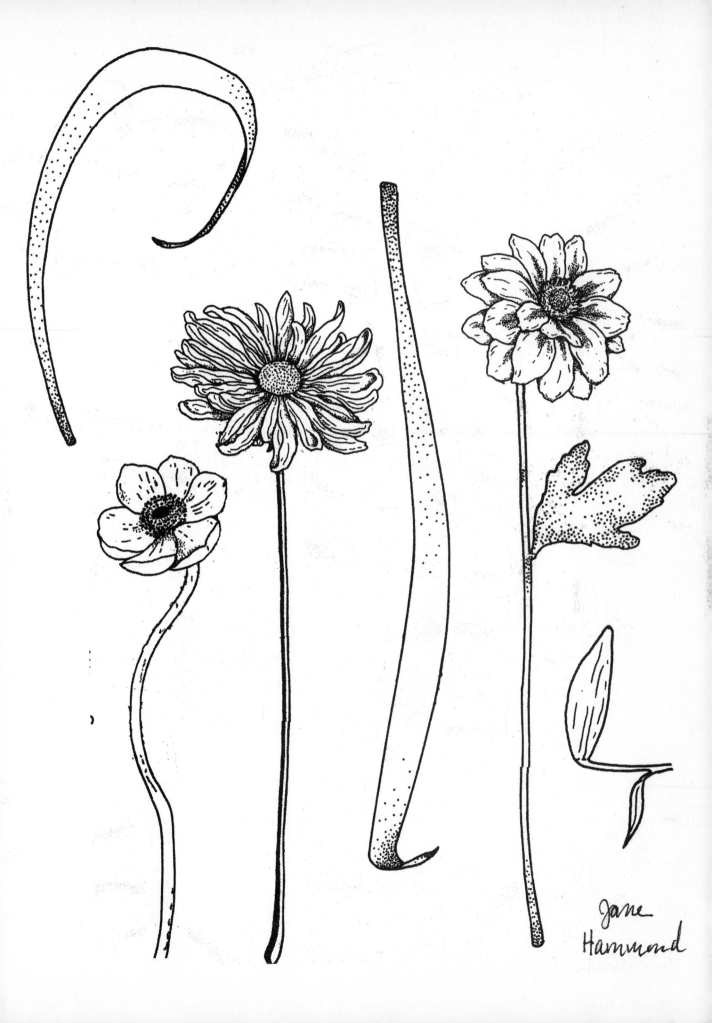

Jane
Hammond

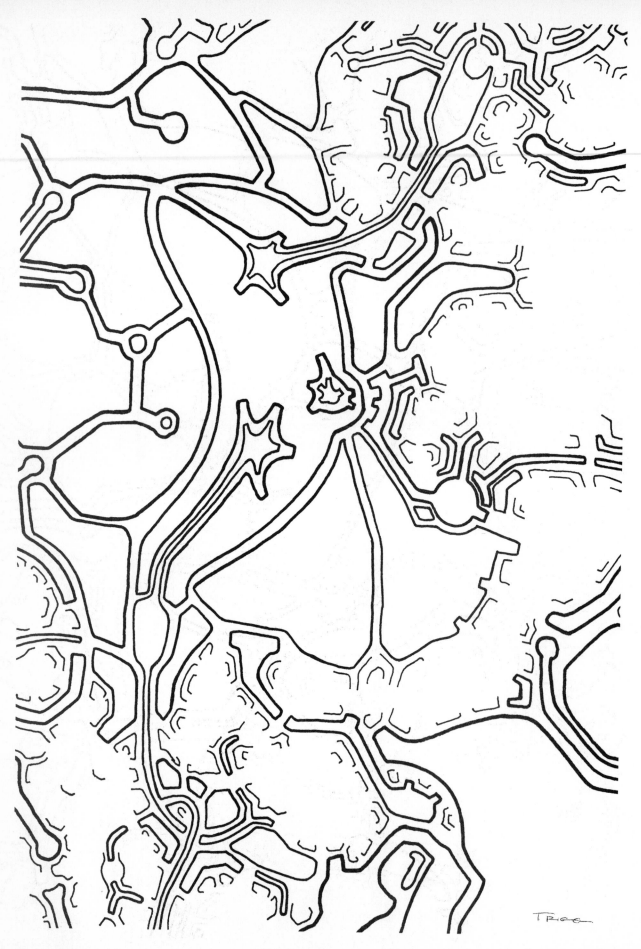

Sarah Trigg

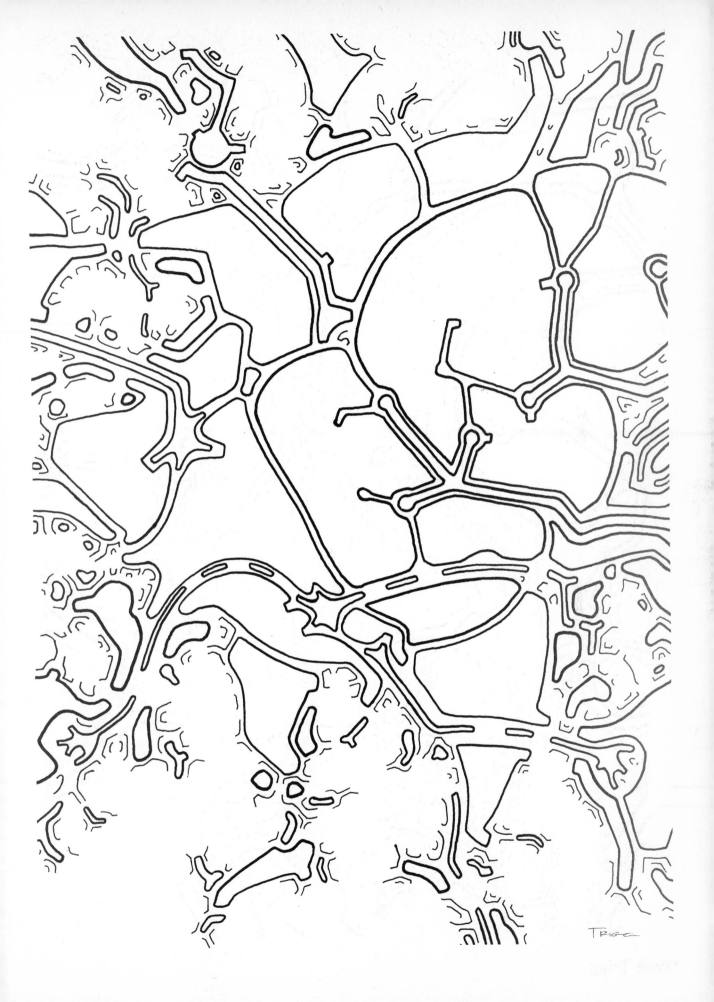

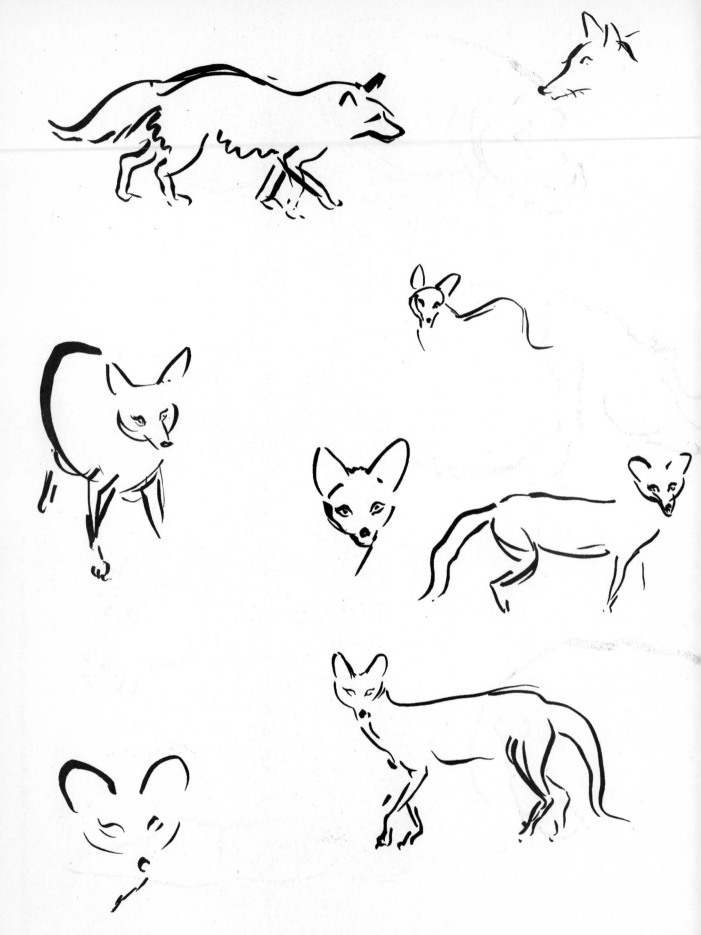

Alexander Calder

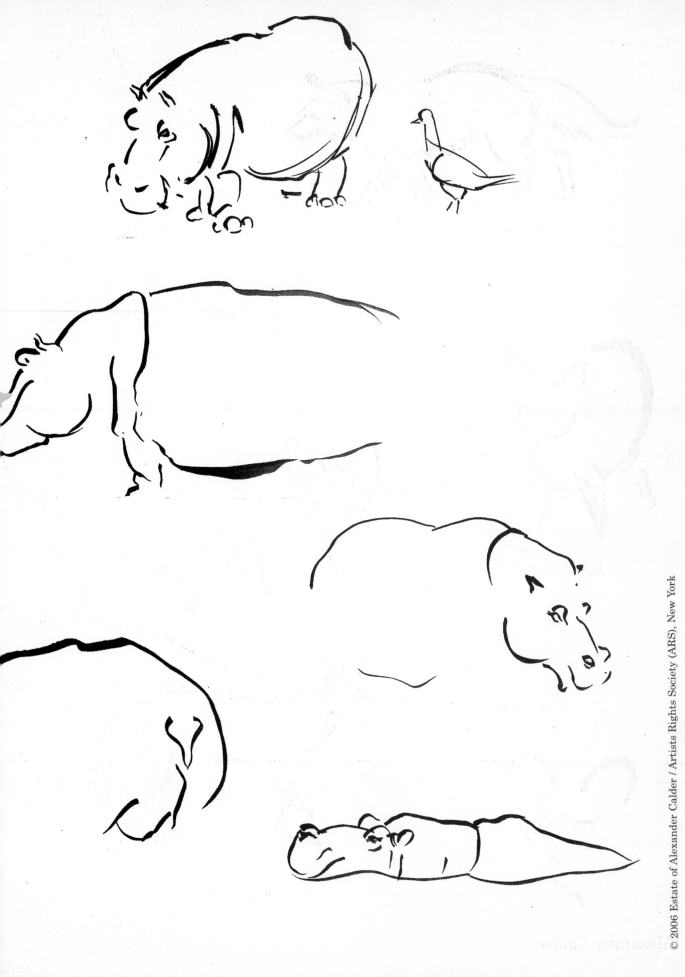

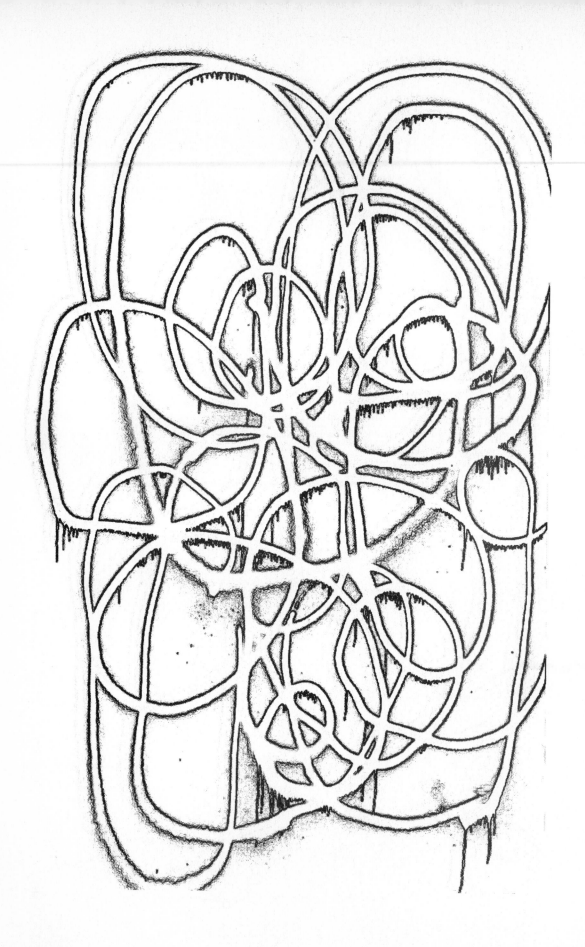

Christopher Wool

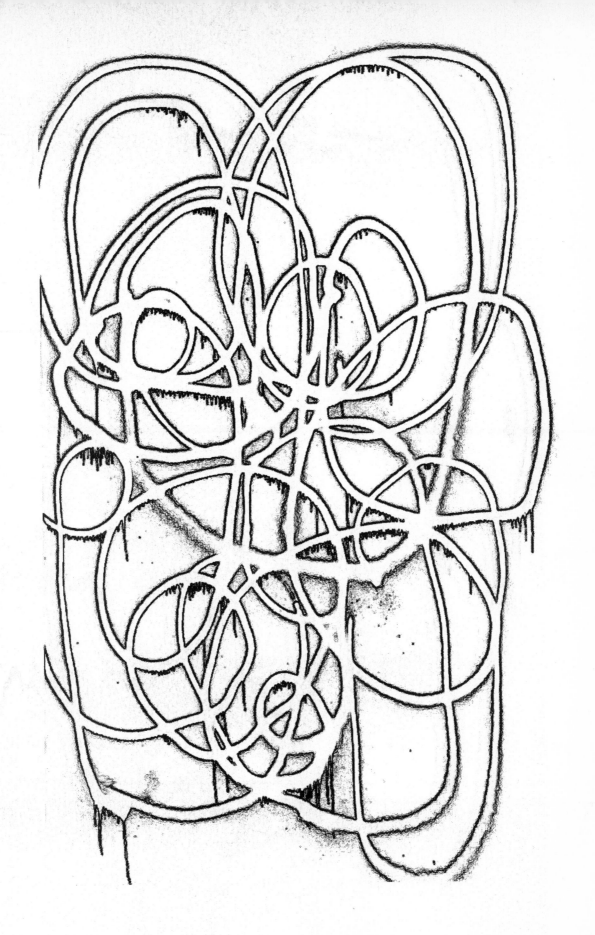

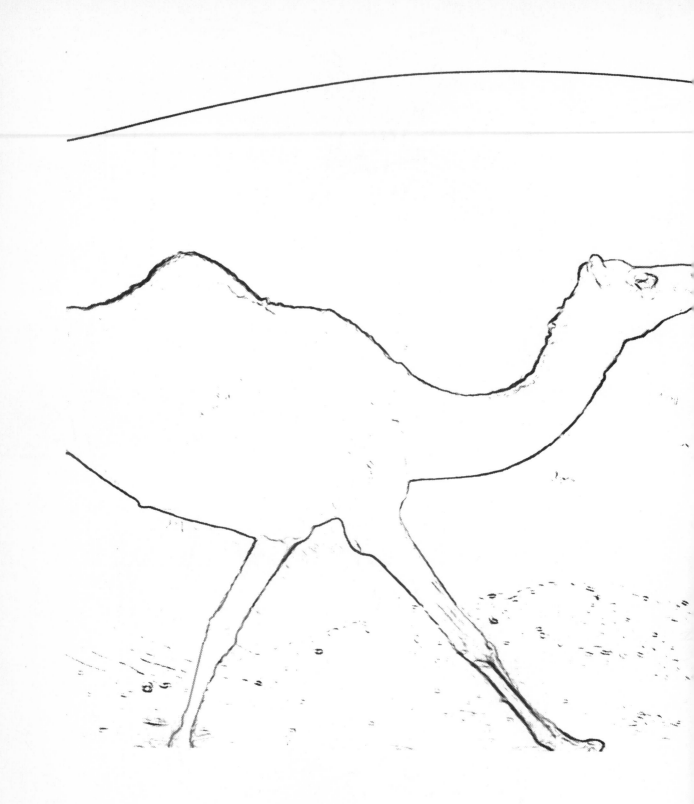

Dennis Hopper

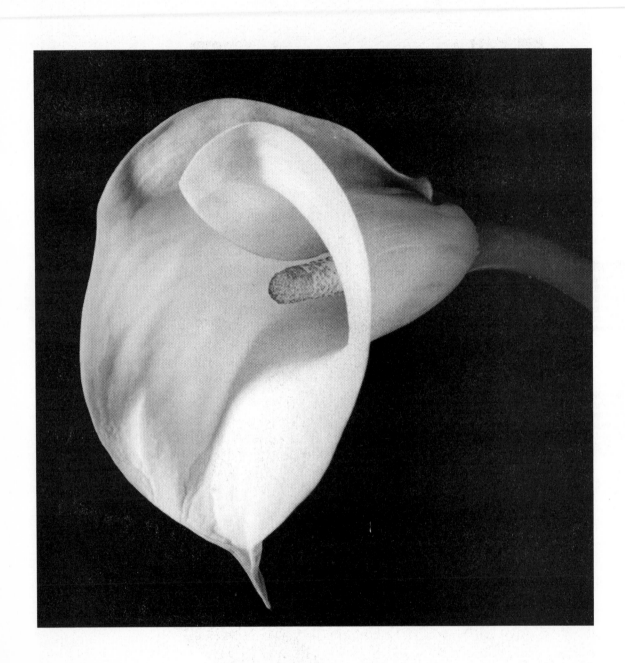

Robert Mapplethorpe

Anonymous

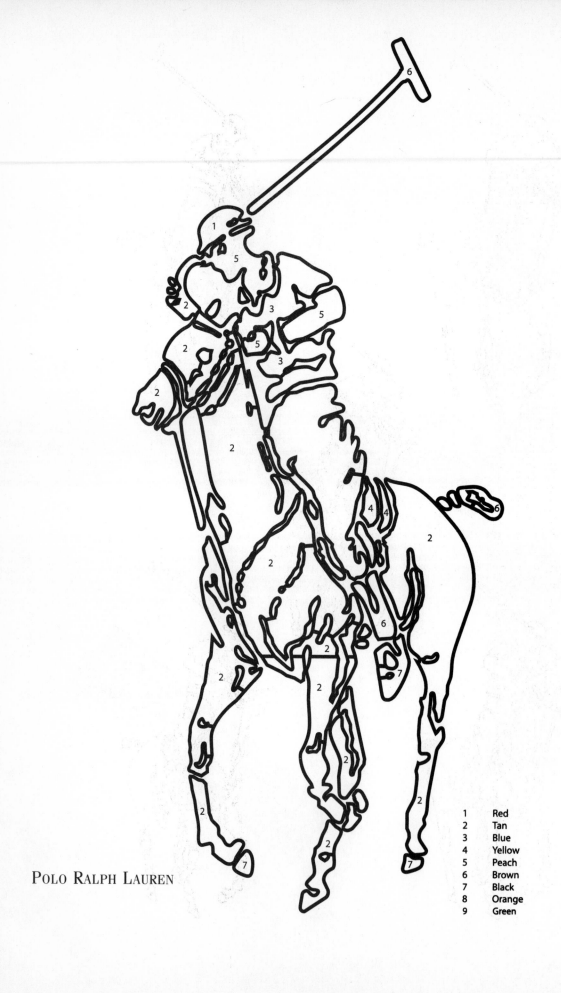

POLO RALPH LAUREN

1	Red
2	Tan
3	Blue
4	Yellow
5	Peach
6	Brown
7	Black
8	Orange
9	Green

Projects

RxArt projects have been installed in the following healthcare facilities:

Children's Advocacy Center, New York, NY
Elizabeth Seton Pediatrics Hospital, New York, NY
Mount Sinai Medical Center, New York, NY
NYU Child Study Center, New York, NY
Rockefeller University Hospital, New York, NY
Schneider Children's Hospital of the North-Shore LIJ Health System, New Hyde Park, NY

Acknowledgements

The RxArt Coloring Book has been an exciting project that would not have been possible without the tremendous generosity of the artists who filled its pages with their work. Their enthusiasm and creativity infuse the book with a joy that will be passed on to each child who sets a crayon to its paper.

The generosity of the following artists, foundations, and galleries have helped make the RxArt Coloring Book a reality.

Vito Acconci, Rita Ackermann, Assume Vivid Astro Focus, Siah Armajani, Chris Astley, Donald Baechler, John Baldessari, Ed Baynard, Libby Black, Jeremy Blake, Alexander Calder Foundation, Willie Cole, Will Cotton, Ann Craven, R. Crumb, Michele Oka Doner, Joel Fisher, Deborah Grant, Mark Grotjahn, Jane Hammond, Duncan Hannah, Keith Haring Foundation, Grace Hartigan, Charles Hinman, Dennis Hopper, Gary Hume, David Humphrey, Neil Jenney, Geraldine Lau, Sol LeWitt, Robert Longo, John Lurie, Robert Mapplethorpe Foundation, Virgil Marti, Ryan McGinness, Jim Medway, Jason Middlebrook, John Newman, Julian Opie, Tom Otterness, Laura Owens, Graham Parker, Maurizio Pellegrin, Lamar Peterson, Alexis Rockman, David Row, Kenny Scharf, Jennifer Steinkamp, Sarah Trigg, Lane Twitchell, Leo Villareal, Andy Warhol Foundation, William Wegman, John Wesley, Christopher Wool

Blum and Poe, John Connelly Presents, Fredericks & Frieser, Sandra Gering Gallery, Marian Goodman, C. Grimaldis Gallery, Lehmann Maupin, Paul Morris Gallery, and Andrea Rosen Gallery. Images by Jeremy Blake are courtesy of Feigen Contemporary NYC.

This project was made possible with the generous support of Polo Ralph Lauren and Modern Publishing.

It takes more than drawings to create a coloring book. RxArt would like to extend our most sincere thanks to the Artists Rights Society, Tamara Coleman, William Hart, Susan Hochbaum, John Maroney, Gina Nanni, Camille Obering, Glenn O'Brien, Polo Ralph Lauren, Jennifer Romanelli, *Vanity Fair*, and the staff of Modern Publishing.

Diane Brown
President

RxArt, Inc.
1 Astor Place
New York, New York 10003

Tel 212.260.8797
Fax 212.260.8798
www.rxart.net

RxArt would like to thank the following artists and organizations for their generosity in supplying the works for this book.

Vito Acconci ©, 2006, Vito Acconci/Acconci Studio (Image adapted to coloring book format)
Rita Ackermann ©, 2006, Rita Ackermann
Anonymous ©, 2006, Anonymous
Siah Armajani, *Floating Poetry Room* ©, 2006, Siah Armajani
Chris Astley ©, 2006, Chris Astley
Assume Vivid Astro Focus, *Garden 4 P+B* and *Garden 9 (Revisited)* ©, 2005, Assume Vivid Astro Focus
Donald Baechler ©, 2005, Donald Baechler
John Baldessari ©, 2005, John Baldessari
Ed Baynard ©, 2005, Ed Baynard
Libby Black, *Prada Keychain* ©, 2006, Libby Black
Alexander Calder ©, 2006, Estate of Alexander Calder/Artists Rights Society (ARS), New York
Jeremy Blake, *2 Untitled Drawings* ©, 2006, Jeremy Blake
Willie Cole, *From Meat Eaters Nightmares Series* ©, 1985, Willie Cole
Will Cotton ©, 2006, Will Cotton
Ann Craven, *2 Drawings (Untitled)* ©, 2003, Ann Craven
Robert Crumb, *Boxing* and *Third Eye* ©, 2005, Robert Crumb
Michele Oka Doner ©, 2005, Michele Oka Doner
Joel Fisher ©, 2006, Joel Fisher
Deborah Grant, *Diversity* ©, 2006, Deborah Grant
Mark Grotjahn, *Untitled* ©, 2005, Mark Grotjahn. All rights reserved.
Jane Hammond ©, 2005/2006, Jane Hammond
Duncan Hannah, *Tarzan Drawings* ©, 2006, Duncan Hannah
Keith Haring, *Untitled* ©, 1989, The Estate of Keith Haring
Grace Hartigan ©, 2006, Grace Hartigan
Charles Hinman ©, 2006, Charles Hinman
Dennis Hopper, *Abu Dhabi Camels* ©, 2005, Dennis Hopper
Gary Hume, *The Coloring Book* ©, 2006, Gary Hume
David Humphrey, *Drawings* ©, 2006, David Humphrey
Neil Jenney, *Felon #2=1997* ©, 1997, Neil Jenney
Geraldine Lau, *Information Retrieval: Buried Treasure* ©, 2005, Geraldine Lau
Sol LeWitt ©, 2006, Sol LeWitt
Robert Longo, *Moon* ©, 2006, Robert Longo
John Lurie, *Baby Elephant in Shower* ©, 2004, John Lurie
Robert Mapplethorpe, *Calla Lily* ©, 1987, Robert Mapplethorpe Foundation. Used with permission.
Virgil Marti, *Untitled* ©, 2006, Virgil Marti
Ryan McGinness, *Untitled* ©, 2006, Ryan McGinness Studios, Inc./RyanMcGinness.com
Jim Medway, *Ramp* ©, 2005, Jim Medway
Jason Middlebrook, *Drawing* ©, 2005, Jason Middlebrook
John Newman, *Bubbles Burst* and *Sculpture on a Trapeze* ©, 2006, John Newman
Julian Opie ©, 2005, Julian Opie
Tom Otterness ©, 2005, Tom Otterness
Laura Owens, *Untitled* ©, 2006, Laura Owens
Graham Parker ©, 2005, Graham Parker
Maurizio Pellegrin ©, 2006, Maurizio Pellegrin
Lamar Peterson, *Untitled (Man Made of Flowers)* and *Untitled (Woman)* ©, 2004, Lamar Peterson
Alexis Rockman ©, 2005, Alexis Rockman
David Row, *You Title It* ©, 2005, David Row
Kenny Scharf ©, 2006, Kenny Scharf
Jennifer Steinkamp, *Hurdy Gurdy Man* ©, 2006, Jennifer Steinkamp
Sarah Trigg, *Organized City II* and *Organized City III* ©, 2001, Sarah Trigg
Lane Twitchell, *Earth* ©, 2006, Lane Twitchell
Leo Villareal ©, 2006, Leo Villareal
Andy Warhol, *Vesuvius* ©, 2006, Andy Warhol Foundation for the Visual Arts/ARS, New York
William Wegman, *Coloring Book Drawings* ©, 2006, William Wegman
John Wesley, *Man Eating Boxing Gloves* ©, 1967, John Wesley
Christopher Wool, *Untitled* ©, 2000-2006, Christopher Wool

Design by Susan Hochbaum, New York